TAKE STOCK PHOTOGRAPHY THAT SELLS

An Hachette UK Company
www.hachette.co.uk

First published in the UK
in 2019 by Ilex, a division of
Octopus Publishing Group Ltd
Carmelite House
50 Victoria Embankment
London EC4Y 0DZ
www.octopusbooks.co.uk
www.octopusbooksusa.com

Distributed in the US by Hachette Book Group
1290 Avenue of the Americas, 4th & 5th Floors,
New York, NY 10104

Distributed in Canada by Canadian Manda Group
664 Annette Street, Toronto, Ontario, Canada M6S 2C8

Publisher: Alison Starling
Commissioning Editor: Frank Gallaugher
Consultant Publisher: Adam Juniper
Managing Editor: Rachel Silverlight
Assistant Editor: Stephanie Hetherington
Art Director: Ben Gardiner
Designer: Jon Allen
Picture Research: Jennifer Veall
Production Manager: Peter Hunt

ISBN 978-1-78157-575-8

A CIP catalogue record for this book
is available from the British Library.

Printed and bound in China

10 9 8 7 6 5 4 3 2 1

TAKE STOCK PHOTOGRAPHY THAT SELLS

DALE WILSON

A guide to the essentials of stock photography: picking agencies, creating metadata, and shooting buyer-friendly images.

PHOTOGRAPHY IS EXPENSIVE.
TAKING STOCK WILL HELP CLAW SOME OF THAT MONEY BACK.
ESPECIALLY IF YOU DO IT RIGHT

CONTENTS

PREFACE

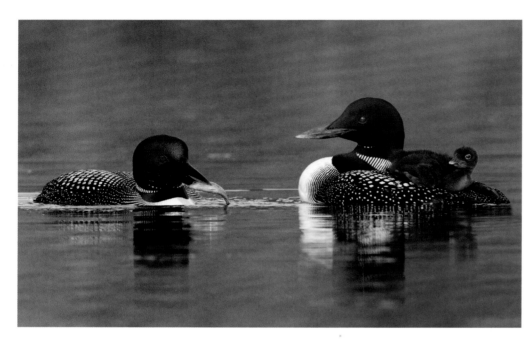

Wildlife portrait

An image of the common loon goes beyond a family portrait. It suggests any number of taglines that convey family, success and nourishment, as examples.

Potential taglines: *Strength in family; Getting the job done; A winning combination; Making the commitment; Success in teamwork.*

Exploring the industry

Stock photography has typically been for the intrepid and itinerant. Whether on the road for extended periods of time or in the confines of a warm studio, the stock photographer is very much left to their own devices to learn the nuances of the industry.

My initial response was to decline the invitation to write a book on producing stock photography. How could I write a volume that would provide *everything you always wanted to know but were afraid to ask* without bringing forward my own biases and prejudices? I assumed the vast majority of readers would be looking for a *how to get wealthy* type of tome, while my understanding of the industry suggests the opposite is closer to reality.

Speaking with several of my peers, I was reminded that I have forged a comfortable living doing what I love. For 30 years I have produced stock photography as a sole source of income. Being a stock photographer was not an occupation or vocation; this was a passion that supported a very enviable lifestyle of traveling the planet doing what I love to do—making photographs and getting well paid to do so.

It was also necessary to look inward and do some serious soul-searching. I worked in an era many refer to as "the glory years," a time when monthly income was measured in tens of thousands of dollars per month. Anyone

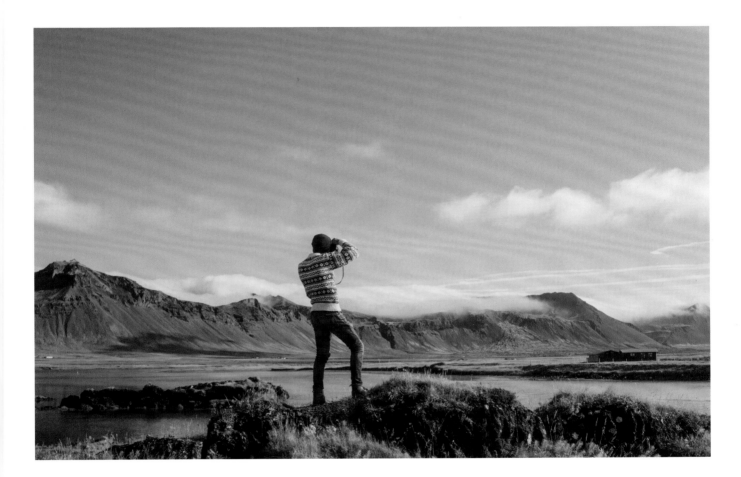

that had a good library of images also had a few in that collection that earned significant accrued royalties—into the hundreds of thousands of dollars per image—over years of licensing history.

Put in context, the average license fee was in the neighborhood of $450 per usage. We could reliably develop an annual revenue budget by factoring $15 per month for each image on file. A monthly sales statement would typically show several sales worth more than $1,000, and it was always fun to see which image might have been licensed for more than $5,000. My record individual sale was a trade exclusive one-year license worth $32,000.

The so-called glory days came to a crashing halt during the 2008 global financial crisis.

The economic meltdown continued well into 2012, with the stock photo industry going through a massive reorganization by way of takeovers, restructuring, and mergers. What evolved was a changed industry with license fees and photographer royalties having been completely redesigned. Gone were the days of stock photographers enjoying income brackets comparable to the best lawyers and doctors in the free world.

Would this be where my bias would reveal its ugly self? Would I become one of those writing of the good old days? In short, was I more afraid of becoming one of the grumpy old men dining on stewed prunes and longing for the past than of sharing accumulated knowledge?

Upon reflection, I also recognized there were topics that have not changed with time. These would be the topics I could bring forward and share with the reader in this book. Image style has changed, but without question, basic concepts have remained constant over time. The dollar value of the individual license may have decreased since 2008, but advertising copywriters still use the same buzzwords as they always have. Consequently, I discerned, this book would concentrate its efforts on how to make "working" photos. I would leave the task of maximizing the income potential of those images with the reader—most likely a far younger and much more cyber-savvy practitioner than myself.

One of the most difficult challenges the novice stock photographer must face is learning how to make a working picture. Regardless of one's specialty, in order to create bestselling images one must learn to transcend their efforts from snapshots to well-executed images that have clarity and a timeless simplicity. This is where I hope to bring the experience of working in those so-called heydays to my modern contemporaries.

I see this work as a passing of the torch, if you will. I may reminisce on occasion, but I hope I have earned that right. I believe that the taglines and buzzwords that worked in the past will also work in the future. The definition of the buzzword *success* is the same regardless of decade or language. The contemporary stock photographer's task is to interpret these buzzwords with a fresh perspective. If just one reader grasps and understands this concept, then I will consider this book to be a success.

That being said, I wish you every level of success. It is not as important to work hard than it is to work smart, for the smarter you work, the luckier you will become. ∎

Contemporary success

The female role in business was at one time primarily restricted to a secretarial or clerical support role. Thankfully this has changed, and the workplace continues to become more equal in terms of gender. As visual communicators, we must be tuned-in to the future: success is success regardless of era, the only thing that will change is how we visually portray that message.

↖

Conceptual success

More often than not, success in stock photography is achieved by making images that are suggestive of a theme rather than a literal interpretation.

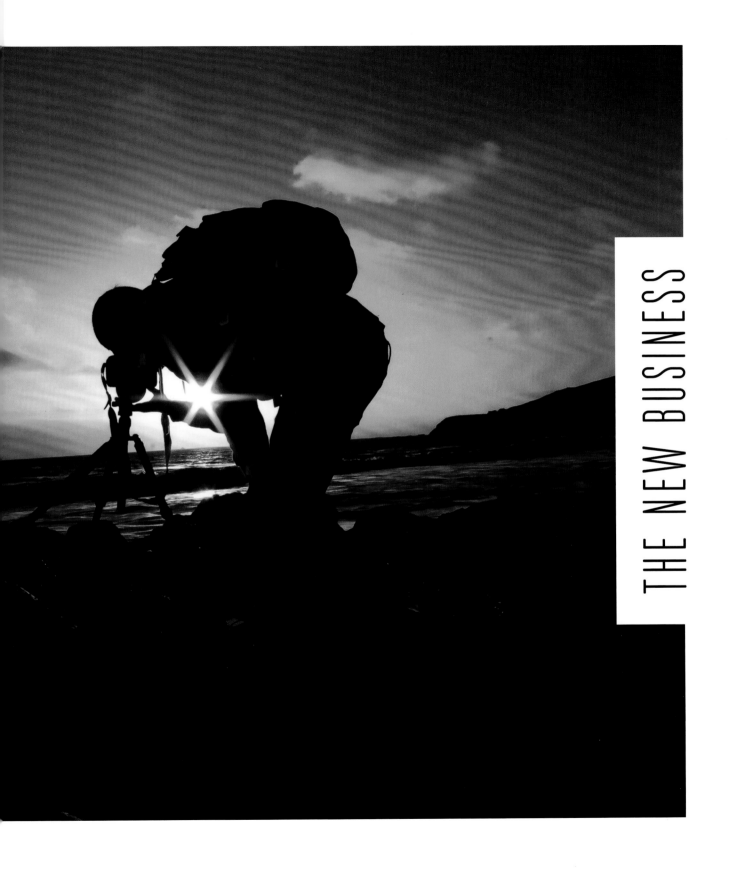

THE NEW BUSINESS

THE NEW BUSINESS: INTRODUCTION

The question often debated among seasoned stock photographers is whether the stock photographer still has the capacity to earn a livelihood from his or her craft. In a nutshell, it would appear that if old business models are utilized—by old, think pre-2008—the chances of success are quite minimal, at best.

The savvy and intrepid freelance stock photographers working today need to have solid, cutting-edge business practices coupled with a creative vision to foresee and execute what will be in demand in 18 months' time, not what is in vogue today.

When smartphone apps first became available, the fashion was to shoot mobile images with a "sepia" app or filter. It was dead-simple to make a current-day photo look as if it were old, and this became a really popular trend. Next came cross-processing, then the grunge look, and a plethora of other effects made available with the adjustment of an app slider bar. As each new trend came along, the photographer who already had their material on file was best positioned to make sales. Meanwhile, the trend-*following* photographers were catching up. By the time they got their material produced and positioned in the marketplace, two things had happened: a new look had come into vogue and the market was now oversaturated with tens of thousands of similar images that were all made yesterday. Consequently, and unfortunately for the trend-following photographer, the return on the investment was insufficient to maintain a positive cash flow. To be successful,

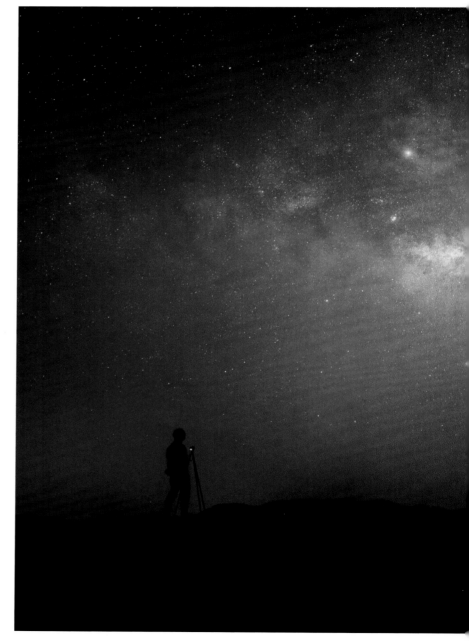

↓

Seeing the light

Understanding and managing
your business cannot be a
shot in the dark. Climbing
that hill of success will require
a large dose of business
cunning, determination,
and a very clear vision.

the stock photographer must be the trendsetter, not the follower.

Monitoring stock photo production over the past few decades suggests image shelf life has shrunk considerably with the availability of digital production and delivery. When I started shooting stock, a picture had an average lifespan of at least five years due to the time agencies required to produce and distribute those big lavish print catalogs. Today, material can be made and begin selling online within weeks of production—if not hours with iPhone upload portals—which means images can potentially start earning income much sooner than in the past. However, this fast-changing market also means photographs have a much shorter shelf life based on the fact that most image libraries' search engines work on a waterfall approach. This means the last image in is usually the first image seen and subsequently pushes all the other images down toward the bottom of the image pool at the base of the waterfall. There is such an oversupply of images that only the very best photographs survive atop the waterfall and continue to make sales after just one year.

With an understanding that image style and trends will tend to adjust in as little as 18 months and, by default, images have an equally short shelf life, the photographer then has to recognize their material must not only produce sufficient cash flow to make the shoot a success, the image has to produce returns on that investment (ROI) quickly before it, too, gets buried among the masses. Herein lays the challenge. ∎

↑
Time management
Most freelance photographers will say the least enjoyable part of being in business is managing the business. At least 50 percent of your time will not be spent working behind a camera, and some photographers suggest that the management takes up 80 percent of their time.

↓
Setting up for success

The challenge when shooting
microstock is to quickly produce
quality images extremely efficiently.

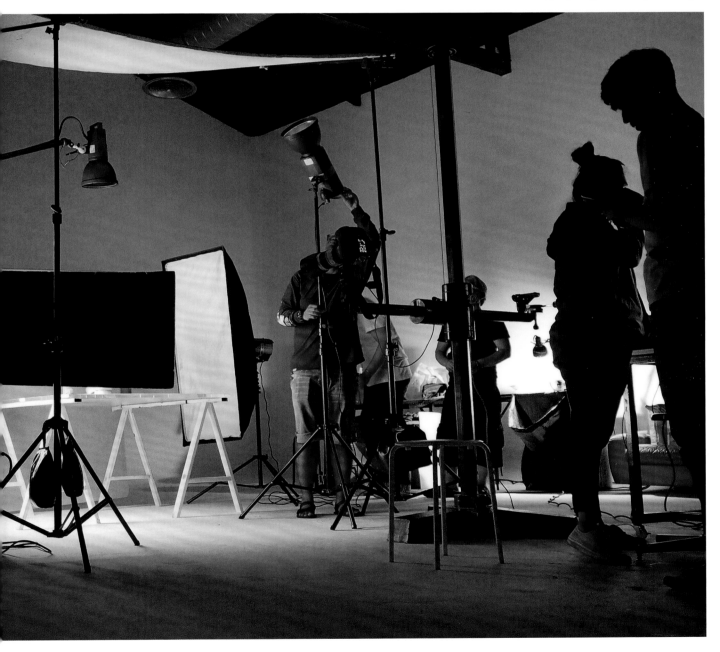

THE COST OF BEING IN BUSINESS

One of the most difficult components of putting together your business will be calculating how much revenue will be required quarterly and annually in order to stay in business. Obviously it is necessary to maintain positive cash flow. Only with this knowledge will you be able to know with certainty how to adjust your operating and maintenance (O&M) costs in order to manage your cash flow and remain solvent.

When looking to reduce your operating costs, the easiest item to remove from the "cost calculator" is "expected salary"—don't do it. If the business does not pay the owner first, then why be in business? It is easy to move the salary expectation up or down as conditions dictate, but always pay yourself first. Beyond the practical reasons of paying yourself, there is also the mental consideration: If your personal income is seen as unimportant by paying yourself last, then what does that say about your actual value? Once you stop respecting yourself, you have lost respect for your business—and you are your business. By paying yourself first, you force yourself to work smarter; not necessarily harder, but smarter.

These calculations will also provide direction, such as whether it is more advantageous to shoot microstock or rights-managed stock, or some combination of all licensing models. Only by knowing that your annual costs will be $112,000 per year (as an arbitrary number) does it become possible to forecast what your revenue has to be per annum to meet your expenses

↑
The art of business
Only when the true cost of conducting business is understood does it become possible to have a clear picture of what your annual revenue must be in order to succeed. The art of photography is about making pictures; unfortunately making stock photographs is not about creating art.

→
Supporting your business
Success can be a heavy burden. It is essential to pay yourself first. Should you opt not to, then why are you in business?

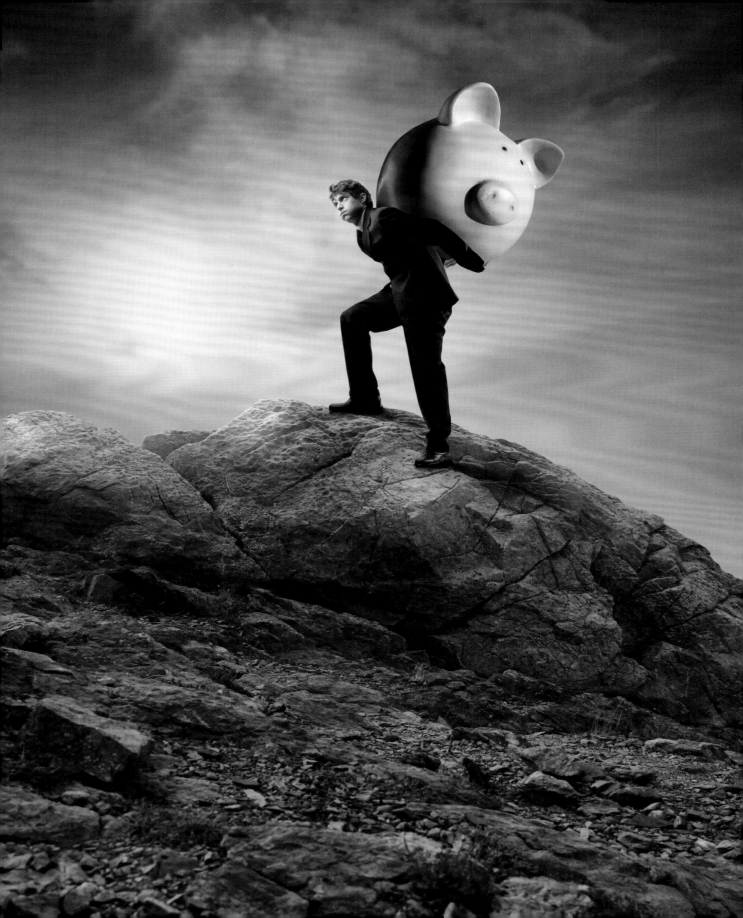

←

Budgeting for success

The photographer will have to develop annual operating budgets, long-term capital investment budgets, and shooting budgets for week-by-week shooting projects. As a start-up photographer, do you know what your time is worth? It should be the most expensive item in the budget overall; time is, after all, your most valuable commodity.

($560,000 based on a 20 percent royalty return). Think about this for a moment: these are realistic numbers and your revenue from licensing stock has to exceed more than half a million dollars annually just to meet your costs of being in business.

Study the data you input into the calculator very closely. Is it possible to rent a condominium suite on a shoot-by-shoot basis instead of a monthly studio in the heart of downtown? Can you find a competent freelance hair and makeup artist as opposed to hiring both a hair stylist and a makeup artist? Perhaps you have a friend that understands wardrobe styling and how not to date an image with trendy clothing.

Should you have an array of equipment that is to be incorporated into your business, you will have to find out from an accountant what the depreciated value might be. This will be required for filing your year-end profit/loss statement, so it is best to have

these numbers fresh from the start. The older your equipment is, the more money you should place in capital reserve from the onset. When your equipment becomes depreciated to zero value, you should have sufficient funds in capital reserve to replace it without requiring financing.

Many photographers today no longer own camera equipment. They recognize it is extremely expensive to purchase and maintain, and rarely is that equipment used more than 50 percent of the calendar year. Renting the necessary equipment for each shoot frees their overhead costs, and the rental fee is 100 percent deductible against revenue as a cost of doing business in that calendar year. You owe it to yourself to consider renting as it can save you money from a variety of angles.

All the little items that can be addressed before starting your business will assist you in making informed decisions with respect to how you manage your business toward a financially successful future. If the stock agency unilaterally controls the selling price of your licensed image, the only control the stock photographer has, as a business owner, is to find ways to produce images more efficiently. It is hard work to work smarter, but smarter you must—to not will be your demise. ■

CALCULATING THE COST OF BEING IN BUSINESS

ANNUAL COSTS

Insurance	$
Office Expenses	$
Business Taxes	$
Business Licenses	$
Meals & Entertainment	$
Bank Interest Costs	$
Delivery/Postage	$
Legal Fees	$
Accounting Fees	$
Administration Fees	$
Equipment Costs	$
Rental Fees	$
Maintenance/Repairs	$
Capital Reserve	$
Vehicle Costs	$
Telephone/Internet	$
Support Staff	$
Other	$
Subtotal	$
Your Minimum Salary	$
Annual Expenses	$

Simply divide the annual expenses by 12 to arrive at the net monthly revenue you must attain in order to maintain a positive cash flow. Add entries that are deemed necessary, delete those that are not.

WHICH AGENCY IS THE RIGHT AGENCY?

Following the 2008 economic crisis, takeovers, mergers, and acquisitions within the stock photo industry seemed to be a weekly occurrence. Keeping up with who owned what agency became incredibly challenging.

More than a decade later, the realignment of agencies continues. In 2016, Corbis Images, one of the largest agencies in the world was sold to VCG of China. As part of the deal, Getty Images would distribute its once bitter rival's collection outside of China. Veer, the successful Corbis microstock imprint, saw its collection embedded into the Getty-owned microstock agency iStock. There were other smaller moves within the industry, but without question the Corbis sale was the real blockbuster.

In April 2018, Blend Images announced it was closing shop. If they couldn't find homes for their content, the files would be returned to the photographers by October 2018. This was a significant announcement on two fronts: Blend had one of the strongest "lifestyle" libraries available in the largest market of North America, and, it would appear, the shareholders weren't even trying to sell the agency. Would this be an indication of the value of agencies going forward?

This recent history brings us back to the question: Which agency is the right agency?

If deciding to seek representation as opposed to acting as an independent

"It is vital for the photographer to really research each of the agencies and study the conditions of the contracts."

↑

Choosing licensing models

There are many, many dozens of agencies to seriously consider before signing a contract. Which of the microstock, royalty-free, or rights-managed licensing models is best suited for you and your content?

→
Choosing representation

Even prior to signing with an agency you will have expended considerable resources in purchasing equipment and acquiring the skills to use those tools of the trade. Where and how will you receive the maximum return for your investment? Is it with a large agency where you will quite literally be a number and not a name, is it with a chic agency that represents leading-edge creatives and demands exclusive artist representation, or are you better off marketing your work independently in your home geographical region, thereby retaining the full reward for your efforts?

stock photographer, you will also need to decide whether to seek exclusive or non-exclusive representation. In order to make those decisions, it is vital for the photographer to really research each of the agencies and study the conditions of the contracts. Beyond that, it's critical to understand how payments are made and what the royalty return is in each situation. What is the photographer remuneration on subscription sales, and individual licenses? Very small differences in percentages can add up significantly over the course of time.

When are payments made, and is there a minimum payment schedule? This might not sound significant at first, but most agencies have a minimum payment threshold before they will remit royalties due to the

photographer. Should a photographer be contributing to ten agencies that each pay annually only when a minimum of $100 is reached, and each agency owes the photographer $99, the photographer will have to wait another year to receive the $990 that is owed. Of course this is completely unacceptable to the photographer attempting to wisely manage their cashflow, so be completely aware of the agency payment schedule in advance of signing the contract.

Most importantly, what are the strengths of each agency in terms of its imagery and is that agency best positioned to place images in the optimum market? Currently there is one platform that is uniquely positioned above and beyond its competitors, and that is Adobe Stock.

↑
Seek legal advice

Most photographers do not understand contracts and legal counsel should be sought to sift through the pile. More specifically, the counsellor should be familiar with photography contracts as you are seeking advice on what is not included in the contract more so than what is. Think of this exercise as risk mitigation and bear in mind that an ounce worth of prevention is worth more than a pound of cure.

TEN MICRO AGENCIES TO CONSIDER

Adobe Stock
..
Alamy
..
Shutterstock
..
123RF
..
Can Stock Photo
..
Crestock
..
Dreamstime
..
iStock
..
Stocksy United
..
Pond5
..

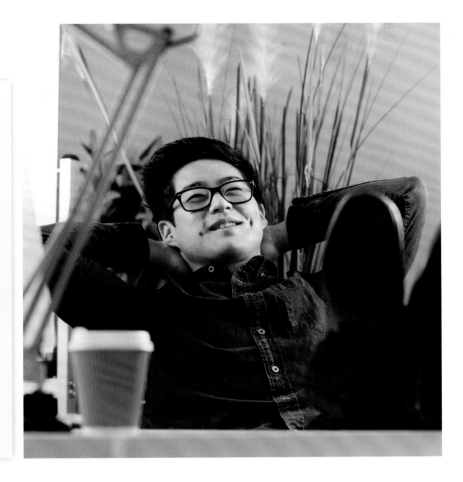

Since its introduction of Photoshop to the graphics and communication industries in 1990, Adobe Systems has advanced its now de facto software through numerous revisions, including the Creative Suite and Creative Cloud versions. It should only stand to reason that if the majority of the world's visual communicators are using Adobe software, making quality image content readily accessible to import into a document with the click of a mouse would soon follow.

That occurred with Adobe's acquisition of Fotolia Stock Images in 2014, and its subsequent introduction into Adobe's Creative Suite in 2015. As a result, no other stock image provider has such direct access to Adobe's massive client list of image users—the vast majority of whom are also the buyers of images—or direct entry into Adobe's design software platforms.

It will be interesting to monitor how Adobe harnesses this strategic position, and how it will benefit the content provider. ∎

↑
The reward of research
With due diligence and a lot of hard work, there is a sense of satisfaction in knowing you have made an informed decision. Stock photography is a business and should not be considered an exercise in personal vanity. You will want to sign with the right agency, not any agency.

TRADITIONAL STOCK

↓

Dramatic shifts

The sharp photographer must be familiar with trends. For several years dark images with dramatic contrast were in vogue. By the time I had finally made this image, designers were looking for high-key, light, and airy images. If the muse strikes, make the image without delay.

T raditional stock has historically been defined by the ability of the photographer to make a photo and resell it many times over, all the while controlling the usage rights being licensed. As a consequence of this hands-on control, the model became known as the *rights-managed* stock photo.

The business model of rights-managed stock evolved through the Hutton Group, Black Star, and Bettman Archive in the pre-WWII time period. Magnum, Associated Press, and a host of upstarts post-WWII continued to lay the foundation for the booming 1980s and 1990s.

As stock photography matured, advertising agencies realized it was often more economical to license a stock photo than it was to hire a photographer to shoot the desired image on an assignment basis. As a result, more and more photographers began shooting stock on a speculative basis and making images to meet the advertising agencies' increasingly higher demands. Gone were the days of stock images being outtakes from commercial assignments or quick grab shots. By the 1980s, stock photography was a genre all to itself, with photographers often managing large-scale studios and production staff. Consequently, the technical quality of images increased to the point where the stock photo rivalled the best assignment photography. It was not long until advertising agencies demanded image exclusivity and this generated the incredible license fees stock photographers enjoyed,

"Advertising agencies realized it was more
economical to license a stock photo than it
was to hire a photographer."

often far exceeding what could be realized by the assignment photographer. There are many, many cases of photographs being licensed for many tens of thousands of dollars. Some sales even reached into the five-zero category.

The contributor/agency relationship, for most partnerships, was equal, with each receiving 50 percent of the gross license fee. Agencies required either an exclusivity contract with the photographer or, at minimum, an image exclusivity agreement. This was solely based on the understanding the agent had to have complete control in how that image was licensed and where it was being used.

This was also when photographers shot film, and agencies delivered the crème de la crème from their collections to the potential client in the form of big lavish catalogs. The photographer worked hard to get their material to a quality high enough for catalog inclusion—it was widely known that if an image was in a catalog, it would most likely become a bestselling image.

This was a labor-intensive process that cost both the photographer and agency a great deal of investment in time, staff, and production to get that image to market. The agencies and photographers that became wildly successful were those that understood what the client wanted and took great strides to meet those demands. You could often hear less successful image producers talk about volume; they incorrectly believed financial success would come by way of critical mass. The successful photographers knew otherwise and quietly went about their business of creating fewer but higher quality images.

The phrase "90 percent of our income comes from 10 percent of our collection" was the mantra to live by. The challenge was to learn why those 10 percent were earning the 90 percent, and by so doing, work more efficiently.

These images that repeatedly sold were found to fall into a core group of categories, such as lifestyle, healthy living, and conceptual genres. It was these same categories that would sell year after year. The astute photographer would keep making images to satisfy the demand from those categories and

↖

Clinical precision

A clean, well-executed image made in the studio could generate a healthy income for many years. With the introduction of microstock, the client could now find similar images with no license restrictions for fractions of a rights-managed fee.

↑

Floating free

For several decades the easy-to-produce images that were laden with color were the bread and butter of the photographer producing images for the only licensing model available at that time—rights managed. As the industry evolved, and photo researchers became more savvy in research methods, this type of image is now available for free.

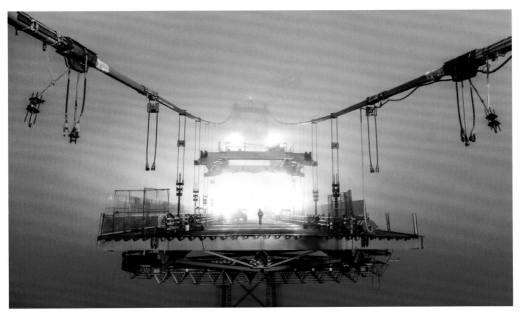

←

Engineering success

Only rarely will assignment work translate to a successful stock photo. This image is too complex to convey "bridging the gap" or various other taglines that might typically be used by a creative copywriter. Similarly, successful stock images have their own unique look and feel and are usually easily identifiable.

RIGHTS-MANAGED MODEL

PROS:

Creative freedom

Typically a higher selling price per image than royalty-free fees

Royalty return is typically at least double that of royalty free

Limited control, in concert with agency, over how an image may be used

Fewer competing photographers than microstock

CONS:

Agencies are now licensing rights-managed images under "subscription," thus lowering the value of license fees significantly

Many agencies covertly no longer accept rights-managed images

License fee structure unilaterally decided by agency

Dramatic license fee decrease as agencies move to capture market share

Analysis: Depending on individual circumstances, it will most likely be more beneficial to adopt a rights-managed business model in a niche image field and market those images independently of RF or microstock to ensure favorable returns on the investment than through agency representation.

learned how to prolong the shelf life of an image with careful styling. It was not uncommon for an image to have sales potential exceeding well beyond five years.

That all changed with the internet and the introduction of royalty-free licensing, which ultimately led to microstock. ∎

ROYALTY FREE

Natural progression

Royalty-free images opened the door to non-professional photographers and they responded with an entirely new and fresh look. The images weren't conventionally stylized and offered the look and feel of snapshots of friends in situ. The clients responded favorably and demanded more, at even lower prices.

F or decades stock photography followed the pricing model of charging a license fee based on a pre-determined usage. Traditional stock was labor-intensive as each license had to be negotiated and compared to a pricing matrix. The model gave both the agency and the photographer the potential to earn healthy incomes.

When clip art entered the equation in the early to mid-1990s, it offered the consumer a really low-quality photo for equally low prices. Clients saw the opportunity to push for better generic images at lower prices than traditional stock, and the agencies responded. Royalty-free images were born and filled the gap between the two hitherto extremes.

Photo District News, the leading American magazine of choice for professional photographers, reported in its January 1999 issue: "Getty Images [then] CEO Jonathan Klein told a standing-room only crowd of stock agents and photographers that the stock industry must automate and make itself more customer centered."

Up to this point in time, photographers were shooting film and absorbing all the costs associated with getting the edited image to the agency. Some agencies were copying the selected image onto duplicating film to have hard copy pictures to courier to clients around the world. Other agencies were making drum scans of the picture, and then outputting to film recorders for the necessary redundancy of multiple transparencies.

As Klein was indicating in his address to those industry professionals, the introduction of the internet and digital cameras was changing the face of stock photography. The benefactor was the client and pixels would be the messenger.

The climate was right to introduce royalty-free images in earnest. Photographers could shoot with digital cameras and eliminate film-processing costs; agencies could store files on servers and eliminate film duplicating services, as well as catalog and delivery costs; and clients could view potential selections immediately in a light box. It seemed a perfect scenario for all.

The client embraced the model and continued to ask for better images. Agencies encouraged their photographers to supply, and they did. Before long clients were asking for even better images, and more relevant images, just like those found in the traditional rights-managed collections. Before long it was difficult to see a quality

↓
Tools of the trade

As camera equipment became more automated it created a brand of
liberated photographers. High-end royalty-free photographers were freed
from the hackles of tradition and were only restricted by their imagination
and creativity. This evolution dramatically improved the visual content
available to clients by replacing assignment outtakes and poorly executed
images with creative working photos produced by photographers that
understood the meaning of a working photograph.

ROYALTY-FREE MODEL

PROS:

Typically has a higher license fee than microstock

Depending upon the agency, typically delivers a higher percentage royalty return to the photographer than microstock

Usually RF images are part of a lightly curated collection, meaning higher quality standards, thus less competition compared to microstock

CONS:

Agencies often demand image exclusivity

Exclusive image representation permits the agency to commission competing agencies to sub-distribute the image, thus reducing the royalty due the photographer by at least 50 percent

Typically offers a lower license fee than rights managed

Currently little distinction between royalty free and microstock in terms of quality

Very limited control in image usage restrictions

Analysis: Royalty-free image licensing will ultimately be displaced by microstock. Serious photographers with a business mind will most likely want to investigate self-representation through a hybrid mixture of licensing models with rights managed to maximize ROI.

difference between the royalty-free image and the rights-managed image.

It was the perfect scenario for photographers, agencies, and clients. Clients could still license the big-money rights-controlled images for full-page ads, and use the more economical royalty-free images for generic filler requirements.

However, the astute advertising agency realized that once they purchased royalty-free images for a campaign, they could archive those digital pictures for use in another non-competing client campaign. As advertising agencies built in-house collections, and reused those images at

100 percent profit, the photographer was being left out of the revenue stream. To compound the issue, agencies started to lower the price of royalty-free images in order to gain market share.

As Klein said in that New York City address reported in *Photo District News* magazine: "Customers expect more and more value at the same cost or even a lower price." The next phase in the evolution of the stock photography industry would take place a decade later, stimulated by the 2008 global economic crisis, and would witness the rapid rise of microstock photography. ∎

↑
Artificial color

Simultaneous to agencies opening their doors to non-professional image creators, Adobe Photoshop was becoming more accessible. This led to a new breed of content created digitally in post production. Many of these images were not technically acceptable in a rights-managed collection, so they started to fill the royalty-free libraries—libraries that marketed quantity above quality.

→

Up in the air

Easy access to libraries, coupled
with easy-to-shoot material, meant
the new photographers producing
royalty-free images were displacing
many similar rights-managed images.
This generated dissension within
libraries and photographers. To
some extent, nearly 20 years after
royalty-free images entered the
marketplace, the bitterness within
the old guard continues.

MICROSTOCK

n the early to mid-1990s, the Canadian desktop publishing software producer Corel started buying large volumes of photographs outright, categorizing them into various libraries on compact disc for resale, and bundling these into the various Corel software packages. These images were often referred to as "clip art," in reference to the often bland illustrations and caricatures used by desktop publishers in order to sidestep the more expensive option of commissioning original artwork. About the same time, the Seattle-based company Photodisc began selling stand-alone CDs of clip art photos.

By 1994, Corel was advertising "gallery discs" complete with 200 photos for a one-time purchase fee, typically $100 or less than $2 per photo. Generally, these were low-quality photos, but the race to gain market share from the traditional rights-managed libraries was on.

By the late 1990s, several traditional rights-managed stock agencies were exploring online delivery models of royalty-free images at rock-bottom prices. The hope was that as the industry matured, royalty-free prices would increase; that didn't happen.

Shutterstock, the largest microstock agency in the world, reported a revenue per download increase of 11 percent to $3.23 per image for the third quarter of 2017. When you consider Shutterstock had a total library of 160 million images at the time, this amounts to a revenue average of $0.90 per image on file. The same report indicates a return to contributors of approximately 27 percent of revenue.

All these numbers, spreadsheets, and financial reports are mundane and boring to most—if not all—photographers. However, in order to develop a successful business model, it is paramount to have accurate numbers from which to work. You can read all the online chat forums or social media posts known to exist, but the fact remains, actual numbers are required to make informed decisions. There is no better place to get accurate numbers than from the financial documents any publicly traded company is legally required to file.

Shooting microstock is very much a numbers game. According to the Getty Images imprint iStock, they represent more than 160,000 global contributors. Shutterstock has 175 million assets available for license; Alamy indicates they are licensing 120 million images and vectors; and over at Dreamtime they have 69 million stock images available for as little as 20 cents per image.

It is quite impossible to give a reasonable estimate as to how many contributors are making stock photos. Likewise, it is impossible to suggest how many images are available to license. Several reports suggest there are more than one billion photos available for licensing and commercial use; that is a staggering number of pictures, suggesting there will be a continued oversupply of visual content.

The numbers being presented are not intended to frighten the aspiring photographer, but rather to give an overview of the current climate. Just as royalty-free images are displacing rights-managed images, so too will the microstock image

→

A numbers game

Microstock photographers were being encouraged to generate many images using the same studio setup. It was believed volume was somehow equated to success. In this situation, the photographer made one photo of the model displaying a blank business card. Then in post production a total of 76 separate images were created by simply changing the message. Would it not be better for the client, the agency, and the photographer to have simply left the card blank and allow the designer to overprint whatever message they desired?

MICROSTOCK
PHOTOGRAPHY

WHAT IS YOUR
COMPETITION
DOING WRONG

PERFORMANCE
INDEX

MICROSTOCK

PROS:

Typically a non-curated collection providing easy access to many agencies

Agencies usually have a fixed fee structure allowing for some degree of business planning

Many agencies now accept images produced from mobile devices negating the need for expensive equipment and in-office computers and production software

CONS:

Extremely low return on a per image basis, often measured in cents

An extraordinary number of photographers are producing microstock images

A phenomenal number of images are being produced each year, making it extremely difficult to be seen

Due to the volume of pictures being produced, images suffer from a very short shelf life before they descend into library oblivion

No control on how images might be used

To capture market share, some agencies are now offering pictures for free, hoping to make up revenue through web traffic and on-screen advertising; these non-license revenues are not shared with the photographer

Extremely difficult to create a revenue stream sufficient to earn a living income

Analysis: License fees can't get much lower (often free), so agencies will start to become more creative in an effort to capture market share. A safe conclusion is that those future initiatives will not benefit the content creators, making it more challenging for the photographer to earn a living wage.

displace the higher valued royalty-free image. The reason is quite simple: as the lower priced image reaches a quality equalling the higher priced delivery model, the client will defer to the cheaper offering.

The challenge will be learning how to be the visible needle in the proverbial haystack—a haystack that will continue to grow. ∎

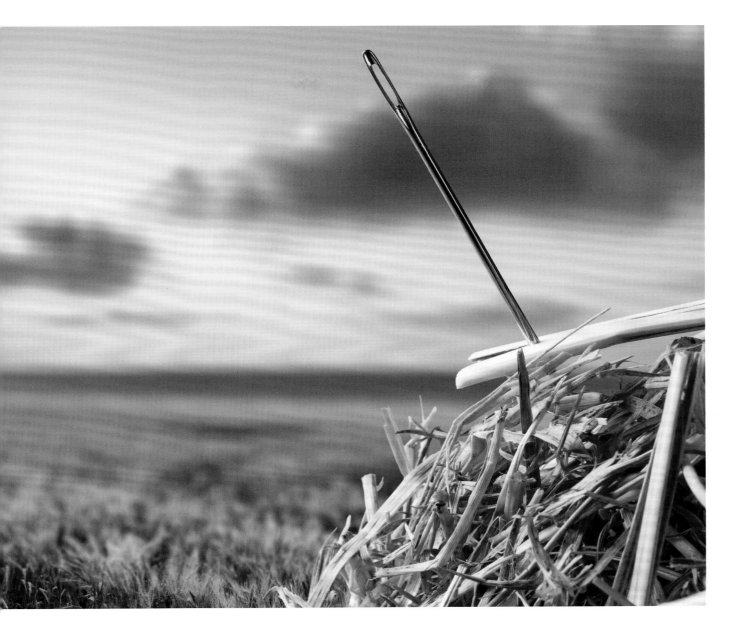

↑

Be easy to find

With reports indicating there may be more than a billion images available for license, and assuming your library of stock photos might number around 1,000 images, it means you make up .0000001 percent of the total library. It would be easier to find a needle in a haystack—unless you can distinguish your work from all the others.

EXCLUSIVE & NON-EXCLUSIVE REPRESENTATION

n the days of rights-managed licensing, a photographer could agree to have one agency represent their works. Agencies worked hard to recruit, train, and represent the artist and this came at a cost to the agency. Consequently, the agency wanted assurances the photographer would also show loyalty in exchange for the coaching. This symbiotic relationship worked, and each party benefitted.

At least one agency even guaranteed a minimum income to the artists they represented. This approach not only assured loyalty, but also placed a burden on the agency to aggressively market and represent their stable of artists.

However, the majority of agencies would sign artists to what were known as image exclusivity contracts, and not photographer exclusivity contracts. This created a problem in the days when image licensing followed the rights-managed model only. Photographers, in an effort to maximize their income potential, would place similar images with competing agencies. It wasn't long before a client that had spent many tens of thousands of dollars to license an image with an exclusivity clause attached would find a similar image being used by a competitor that was licensed from a second agency. This system of one photographer, two similar images, and two agencies was soon found to be an administrative and legal nightmare.

This was part of the reason behind the introduction of royalty-free images. A client could license an image with the advance knowledge there was no exclusivity for a

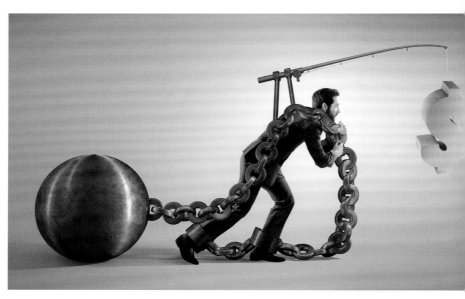

much reduced fee. In theory, if not in practice, the money saved from the reduced licensing fees could then be directed toward assignment work by the client.

The astute photographer recognized that exclusivity was no longer a necessary ingredient in the royalty-free licensing model. They understood that more and more clients were gravitating toward the royalty-free licensing model, and that only the agency benefitted financially from photographer or image exclusivity.

Traditionally, the rights-managed licensing model returned 50 percent of the license fee to the photographer with the agency retaining the other 50 percent. As license fee values decreased with the royalty-free model, the agency also saw a corresponding decrease

↑
The burden of exclusivity

Signing an exclusive contract with just one agency can be a huge weight that may restrict your financial growth. The basic premise rests with the fact that should an agency be sub-distributing a photographer's images, they aren't doing so for free.

in revenue and unilaterally decreased the photographer percentage to 40 percent. Eventually, as microstock entered the equation, which is essentially the RF model at ultra-low prices, the agency continued to unilaterally decrease the photographer's royalty.

There is little benefit given today's climate for the photographer to enter into any exclusivity agreement with an agency. Some agencies will offer a 10 percent increase in royalty for that exclusivity, however the math suggests the real value is in having the image with as many different agencies as possible.

The logic rests in the fact that if an agency has the photographer's image on an exclusive contract, the agency can then redistribute that image to many different distributors or sub-agents. Agencies will never indicate what the sub-agent retains as a commission for licensing the image, so assume it is 50 percent. The photographer receives 30 percent for providing the exclusivity; that is 30 percent of the amount received by the agency they are under contract with. Therefore, if the original selling price was $10, the photographer's agency would receive $5 of which the photographer would receive $1.50. Should the photographer have placed the image with the sub-agent initially for the reduced royalty of 20 percent, they would net 50 cents more.

It's vital that the photographer thoroughly understands the contract in advance of signing. Don't be swayed by vanity or emotion—currency has neither, thus, neither should the photographer. ∎

↑
Golden opportunities

There is no golden egg that will fly today's content creators off to a photographer nirvana. It will be necessary to spread your wings far and wide by diversifying your portfolio.

GOING INDIE

Make no mistake, this is one bold move, and it should not be undertaken as a leap of faith, but as the result of well-informed decisions. It must also be accepted that managing a new business venture will consume far more time than you can imagine. This will be time not spent working on making images.

The independent and self-marketing photographer will need to acquire the same infrastructure that keeps the stock agency in business. This has little to do with photography and everything to do with business administration: financial and tax record-keeping, sales and marketing, among many other business functions.

While continuing to shoot and develop skills, it is also imperative to learn the rules that apply to not only the photography industry but also general business practice. If those rules aren't understood and adhered to, the day will come when the referee calls. Often that referee is an auditor—also less than affectionately known as the taxman, or worse.

The business will have to carry all-encompassing insurance, including for errors and omissions, liability, equipment, loss of business, and building insurance for a litany of reasons. Should the business be managed and conducted from a home office, any existing insurance coverage will most likely not apply. Does the existing home policy cover all peril on office equipment and photography gear? And the questions continue: it is necessary to make a list and consult with a professional for advice on this most important topic.

Some might argue it is not necessary—others disagree—but you will have to consider whether to engage professionals with IT and marketing expertise to build you a web portal and market its content once it is live. It is of little value to be sitting on the best collection of niche images in the world without the knowledge and expertise to get them seen and ultimately licensed.

Most photographers are just that—photographers; we make pictures. What do we know about SEO, how do we maximize keywording to have a positive influence on web-based searches? Do you understand the demographic that is using each mobile device, and how they are using those devices?

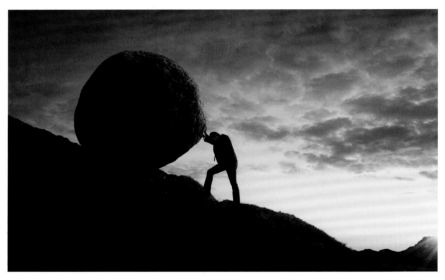

↑
Managable targets
Managing the business will often feel like pushing a large boulder uphill. It is best to break this momentous task into smaller and more easily managed goals.

Responsibility to your business

When the decision is made to forge ahead as an independent, the title of photographer is placed to the side and the new description will read entrepreneur. The novice entrepreneur will quickly learn there are more rules and regulations governing their business than they could have possibly imagined. The tasks can be daunting and the challenges must be faced head-on rather than burying your head in the sand.

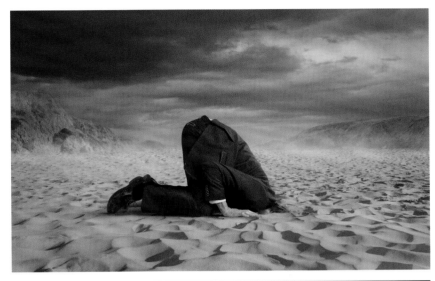

Should the image catalog be based on a home server—and if so, is there necessary bandwidth capacity? Or is there value in cloud or subscription-based services? Unless the workings of the IT world are thoroughly understood, my suggestion would be to contract independent expertise to assist in this capacity.

The same can be said of marketing. Unless you have the confidence to utilize social media effectively, you should consider contracting a new media marketing manager. The bottom line is that if potential clients can't see your material, those images will most certainly never be licensed, which ultimately results in lost revenue.

As any successful business manager knows, the business is only as good as the employees or contractors hired to work on the project. Be wary of friends who offer free advice, and live by the credo that you generally receive what you pay for. Should those friends be so convinced this new venture is a recipe for success, ask them if they would like to financially invest. You'll soon discover just how convinced they are.

Be diligent when researching whether or not to forge ahead as an independent. Research could very well show that contributing directly to an agency might prove a better option. ∎

Road to success

As each goal is successfully achieved, the warm fuzzy feeling you get as a result becomes more gratifying, allowing you to focus on looking forward as you progress along your career path.

LICENSING PHOTOGRAPHS

←
Copyright

Licensing images requires the photographer to have a solid working knowledge of copyright legislation, or a counsellor on retainer to provide that advice.

n almost all cases, the copyright of a photograph is automatically assigned to the person who made the photo, and as such they are identified as the owner of the copyright. Although it varies from country to country, copyright legislation tends to specify that only the owner of the copyright has the authority to license reproduction rights for the image where they have asserted ownership.

The owner of the copyright may also grant a third party the right to assign licenses on their behalf. Such assignment is the very nature of how stock photo agencies work—negotiating usage licenses on behalf of the owner of the copyright for a percentage of the license fees secured. Once you discover how much work is involved in negotiating, licensing, invoicing, collecting, tracking, and turning a lawyer on any

unscrupulous souls that think your photo is public domain, the agency commission rates quickly become much more understandable and palatable.

If you've decided to go "indie" in order to maximize your potential financial return, there will be licensing considerations to take into account. All images will require a license, regardless of whether they are licensed under a royalty-free or rights-managed model. Every license agreement must spell out the terms and conditions regarding the use of that image and most importantly the termination date of the license. These terms and conditions are best addressed by having legal counsel from someone who specializes in intellectual property law—review existing industry standard licenses and adapt them to meet your individual business requirements.

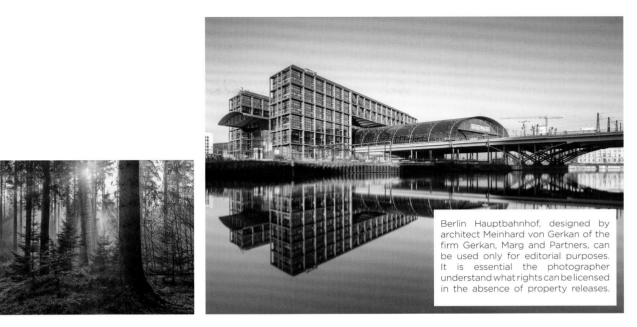

Berlin Hauptbahnhof, designed by architect Meinhard von Gerkan of the firm Gerkan, Marg and Partners, can be used only for editorial purposes. It is essential the photographer understand what rights can be licensed in the absence of property releases.

The minimum fee that must be charged for the license will be determined by a range of factors relating to the usage of the image. A useful resource, and one of the best available for stock photographers, taking into account all factors of usage and using them to determine a fair fee, is the product line from Cradoc fotoSoftware. Their program fotoQuote offers pricing guidance and brings years of licensing experience into the equations, while fotoBiz populates an amendable license printout as part of the quotation and invoicing process. One of the most difficult challenges facing the start-up business is finding solid baseline data that is reputable and proven. The Cradoc fotoSoftware range deserves consideration whether licensing rights-managed, royalty-free, or microstock images.

Most frustrating to stock photographers, and their agents alike, is copyright compliance. Unfortunately, the very medium that has provided untold opportunities to market to massive audiences is also the same medium that has created an ill-informed audience. The internet has created a mindset where many users believe images found on the internet are in public domain and are indemnified by the Digital Millennium Copyright Act—or a plethora of other excuses to avoid having to pay for the reproduction of an image.

To the photographer, the image is their means of livelihood, and, by default, occasions will arise when it is essential to assert their intellectual property rights. This assertion will be particularly necessary to safeguard the integrity of rights-managed images. There are a variety of reverse image search tools available for free, such as Google Images and TinEye. However, for a full service that conducts searches and collects fees on your behalf, look to high-end providers such as PicScout and ArtistDefense Incorporated. For a fee, typically based on what is recovered, these firms are very successful in doing the dirty work of copyright compliance.

Licensing images can be a daunting task, requiring more tentacles than the most ambidextrous octopus. Thorough research of all the options is essential prior to deciding what licensing model is most suitable, or whether the best course of action is to seek agency representation. ■

Taking credit

You can try to protect your images online with the use of watermarks that place your credit line over the image. Anyone wishing to use your image will have to contact you for an unmarked version, at which point you can present a license agreement for the image. Photographers are continuously wooed by image users who suggest what a great honor it would be for you to provide them with a free photo in exchange for a photo credit. The fact remains they are compelled by law, where practical, to assert the photographer's moral rights. Contrary to popular believe, photo credits do not generate sales for stock photographers.

Property releases

The photographer is also ultimately responsible for knowing whether an image can even be licensed. The modus operandi should be to secure a property or model release even before the photo is made, thus eliminating any uncertainty or unnecessary risk. Ignorance will not be an acceptable defence.

THE LEGAL STUFF

Disclaimer: The following is not intended, nor should it be interpreted, as legal advice. The reader is strongly encouraged to seek legal counsel for every facet of their business with specialists in that field.

Do I need a lawyer?

Yes.

Photographers understand f-stops, shutter speeds, and light. Most photographers do not understand the hitherto that could potentially and negatively affect the hereinafter. It has been said that a lawyer is his own worst enemy. The only thing potentially more dangerous is a photographer acting as their own lawyer.

The fact remains, most photographers have never read the legislation that protects their primary interest—the copyright in their work. If this is the case, then how can you be sure who has the legal authority to sell or license an image? Or, if the copyright in an image is sold, are moral rights also sold with the copyright? These are very, very basic questions and every photographer must know the answers.

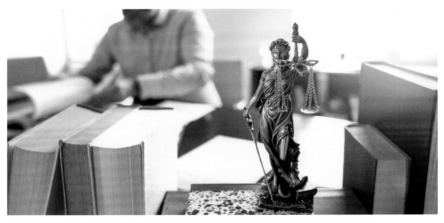

If representation is being sought through an agency, a contract will eventually be presented that will require agreement to the terms by way of signature. It is rare for a photographer to understand all the implications found within an agency contract, or recognize whether recourse is available should something go askew. Has the agency underpaid, or are they in arrears of due royalty payments? What happens to the collection and due royalties upon the death of the photographer? The questions are limitless, and only a lawyer can interpret the wording without prejudice and advise accordingly.

Should the photographer decide to market their own material, the requirement for solid

↓
Seek a specialist

Just as doctors will often specialize
and practice within a particular field,
so too do lawyers. The general law
practice can advise on many different
topics but typically will not be able to
offer solid advice on matters specific
to photography concerning contract
and intellectual property law.

legal counsel grows significantly. For
example, is a model release a contract,
and what are the requirements to execute
that contract? How does one draft a license
agreement? What are the minimum
requirements necessary to ensure corporate
indemnity while preserving intellectual
property in the work? Should the business
incorporate or operate as a sole
proprietorship? What are the minimum
legal requirements for filing the various tax
documents with each respective government
in that area of jurisdiction? And the list
continues ad nauseam.

Regardless of whether you are seeking
representation or "going indie," the primary
reason to have every contract, agreement, or
transaction properly represented is to ensure
there exists minimal opportunity for
misunderstanding once the business is
started. It can be argued that anyone can
draft the necessary documents from the

multitude of sample templates available
from internet sources; however, this is
akin to seeking cardiac care from an
online cardiologist. Just as the snake oil
the itinerant doctor was selling at country
fairs in the 19th century was potentially
dangerous, so too is the modern online
lawyer found on social media.

While the cost of legal fees may seem
daunting to a start-up business, they are
essential and must be considered when
developing your business plan. It will be
far, far less expensive to retain the services
of legal counsel upon start up rather than
later when potential remedy is being sought
through the courts due to an oversight.

At the end of the day, no photographer
should have to say *mea culpa*. ∎

↑
Protecting intellectual property

As much as the internet is a benefit,
it is also a curse. Unfortunately it has
assisted in developing a large
community that believe an image on
the internet is in public domain by
default. These catch-me-if-you-can
artists will usually only respond to a
sternly worded cease and desist
letter from Lady Justice.

RELEASE FORMS

n the past people would be flattered by seeing their likeness printed in a local newspaper or magazine. Same goes for the architect of a uniquely designed museum, or a homeowner who is proud of their grounds and traditional-style home. However, as a consequence of far too many people being exploited by photographers, and properties being used in marketing campaigns without permission, release forms have become a necessity—this is a good thing.

The release form should not be considered an added burden in the pursuit of just wanting to make photographs, but permission to actually make the photograph in the first place. Once the photograph is placed in any environment other than a rights-controlled marketplace, the photographer has absolutely no knowledge or control over how that image might be used. Thus, it is imperative to have signed releases in advance of making the photo, not after.

This cannot be emphasized strongly enough: Model and property releases also serve to protect the photographer from any civil legal action that might come as a result of the image being published. The release does not serve as immunity, but it can most certainly prove to be a deterrent against possible claims. The responsible publisher will also want to know the image has been released as they too will want to avoid potential legal proceedings. Therefore, the release form has the potential to not only protect the photographer, but will also serve to elevate sales potential, as without one the image cannot be licensed for non-editorial uses.

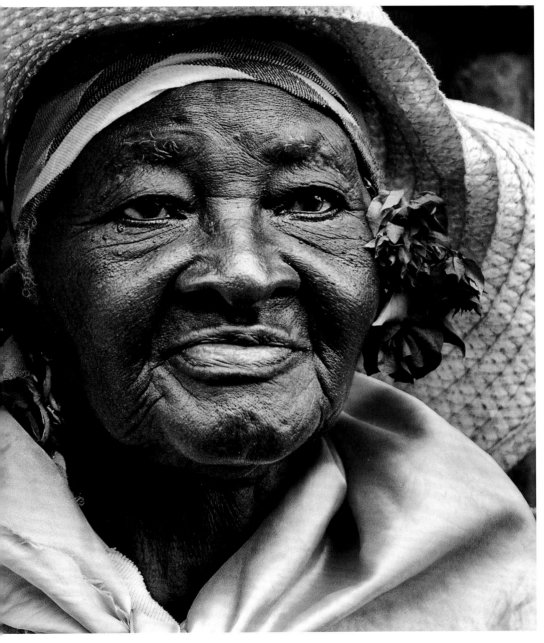

←
Photographing people

There are occasions when even the best preparations are simply not sufficient, and a model release cannot be secured. This street performer would not sign a model release due to an inherent distrust of anything official-looking. Knowing I could still use the image for editorial purposes without a model release, I only took this one photo and compensated her more favorably than what was offered in my introduction letter, or what she was charging. As photographers in a foreign country, we must recognize the sun will still rise the next morning regardless of whether we got the image or the rights we were seeking and provide due respect to those we wish to photograph.

The most interesting and salient components of release forms have little, if anything, to do with copyright. The first consideration to be aware of concerns contract law. Each country has different laws governing the execution of a contract, however, the laws are similar enough that the photographer should be aware of the "flavor" of the law. Somewhere in that model or property release there must be a line that reads: "For valuable consideration received . . . " or words to that effect. In order for the execution of a contract (a release form is a contract) to be legally binding, there must be an exchange of valuable consideration, normally interpreted to mean the currency of that country. In most countries, the minimum deemed to be legally binding is the exchange of one dollar, euro, pound, or equivalent.

The second consideration to be aware of with release forms falls under the country of jurisdiction's privacy and publicity laws. Much like contract law, most countries' privacy laws are similar in nature. Generally speaking there is no requirement to have a release form for photographs of a person taken solely for journalistic, artistic, or literary purposes. However, for all other purposes—whether commercial or not— a release is required due to invading that person's right to privacy and right to control the public distribution of their likeness.

Trademark law is another statute that can prove challenging for the photographer. Common wisdom suggests a photograph should not include an identifiable logo of a brand. The shape of a car, recreational vehicle, or designer furniture may also be covered under (designer) copyright and

APPS

There are many release form apps available for mobile devices across most major operating systems. Care should be exercised to ensure the agency will receive the app profile you have loaded. Many agencies have their own app which they insist photographers use, and this is recommended as the agency will have had it scrutinized by legal counsel. Finally, it is strongly recommended that once the release is completed out in the field, it is immediately transmitted to a secondary repository such as your personal email or ftp account. Mobile phones are notorious for disappearing in water or getting run over by cars (not that I would have experienced this . . .).

registered trademarks. It is ultimately the photographer's responsibility to be aware of any such statutes or covenants in place that protect an object from being photographed for commercial purposes.

Considering the very nature of stock photography as a commercial enterprise, it should be considered essential that all images of people and identifiable places and things be appropriately released. In fact, it is a good habit to get the signed releases before making the photograph. ■

→

Making a good impression

This is an example of an "introduction note" I used when on assignment in Cuba. When I saw an interesting person, a simple universal smile and hello in their language would typically start the process. I then presented my introduction paper, asked them to sign it and complete the model release. At that time, I paid the agreed amount, and only then did I make any pictures. More often than not, I usually have some additional items in my camera bag to leave with my subject as a gift. For example, in Cuba, I landed with complete sets of nylon guitar strings that I gave to those who were especially helpful. (The focus was on street music.) I always have release forms and introduction notes translated by a professional translation service before departure. Do not use online translation sites—they are not accurate, and this is a legal document.

Hello,

My name is Dale Wilson.

I am a photographer from Canada and I would like to take your photograph for publication in magazines.

May I do that?

Would you please sign a paper saying that you know I took your photo?

I would like to pay you 10CUC pesos for this.

Thank you very much.

…

Hola

Mi nobre es Dale Wilson.

Soy fotógrafo de Canadá y quisiera tomar su fotografía para la impresión en compartimientos y los libros y los periódicos.

¿ Puedo hacer eso?

¿ Usted firmaría por favor un de papel diciendo que usted sabe que tomé su foto? Quisiera pagarle 10 Pesos Convertibles de CUC esto.

Gracias mucho.

PHOTO CONTESTS

Photo contests have evolved to become the bane of every stock photographer's existence, or should be seen as such. They are an evil blight that collectively and annually erode many millions of dollars from potential stock photo licensing fees.

For those wanting to earn a living—or even a modest income—by creating stock photography, it's important to identify those that prey on a photographer's vanity. Be cynical and be honest with yourself and your industry.

It is critical to have a working knowledge of copyright and the language of legalese to understand the fine print. To not is akin to giving away money—your money!

Prior to the internet and the resulting industry evolution, photo contests were useful. Most often contests were hosted by magazines for the sole purpose of promoting the science and art of photography. A winning entrant would receive copies of their image printed in that magazine, which could be used to create tear sheets for a portfolio. Rarely did a contest host ever retain rights to an image other than first publication rights and the right to use the image to promote future contests.

In the late 1990s to mid-2000s, along came the perfect means to adjust, amend, and "season to taste" contest entry requirements. First publication rights transformed into this actual copy:

Honor thyself

Religious organizations often hold contests in order to secure free images to produce calendar products that are used as fundraising initiatives. I always ask if the organization has paid staff, or, if the designer or printer are working for free. If these folks aren't, then why should the photographer?

"By entering the contest, you retain the rights to your works while granting [sponsor's name] the unrestricted, royalty-free, perpetual right to use, reproduce, communicate, modify and display the works (in whole or in part) for any purpose without any fee or other form of compensation, and without further notification or permission . . . "

In essence, the contest host could now use an image indefinitely without any compensation to the photographer whatsoever—and not just the winning entry, but all entries. The term that evolved was "rights grab."

Advancing the clocks forward even closer to the present, the terms of entering a contest have become even more extortionate, as well as more hidden. These are the actual words promoting participation in a contest: "All you have to do is snap and upload your photo of a XXXXXXX destination and

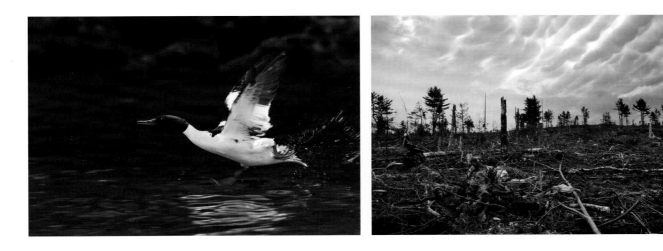

you're automatically entered." There is no prompt to direct entrants to the contest rules, or to understand the 2,740 words of what the entrant is agreeing to simply by entering, such as, in part:

"By participating each entrant represents and warrants that:... the submitted Photo has not been published ... each entrant agrees to assign to the Sponsors and their respective affiliates, on a non-exclusive, perpetual, irrevocable, and royalty-free basis, all intellectual property rights and other property rights in and to the submitted Photos. Each entrant hereby waives and relinquishes such rights in the Photos, including all moral rights ... entrant agrees that Sponsors may, without any additional consideration to the entrant from any party, publish, copy, distribute, broadcast or otherwise use the Photos, for the purposes, in the way and at the frequency determined by the Sponsors in their sole discretion (including without limitation for advertising or commercial purposes), on any medium or support, worldwide and in perpetuity. The Sponsors shall have the right to use the Photos at their discretion, including the right to alter, modify or rearrange such Photos."

To reiterate, this partial extract is actual wording from a 2017 contest's entry rules. Not only has the entrant agreed to give up

the right to have their name associated with the photo (legally known as waiver of moral rights), they have also agreed to basically relinquish all rights to the image. The question becomes: What value is there in copyright without control of the intellectual property in the work?

The bottom line is this: You should never enter a photo contest thinking it will be a tool to advance your stock photography career. That simply will not happen, and particularly so when you have also waived your moral rights just by entering because you will have also relinquished the previously legal obligation to have your name forever attached to the photo as the creator.

No one works for free. Why should the photographer? As photographers it is paramount to consider our peers. While this may be an avocation for some, it is a sole source of income for others, and we must collectively respect the ability of these photographers to earn a livelihood.

No photographer is more important than the industry itself. We owe it to ourselves to allow the industry to remain viable as a career choice. ∎

↑
Enviromental concerns

Images that that have a strong negative component are rarely used outside of the editorial realm, and almost never as a rights-managed image. Consequently, they could be suitable candidates for photo competitions. Be wary and read the so-called fine print; it is quite possible you are also giving up your rights to financially benefit from future sales an NGO might make from your work.

↖
Demand for wildlife

While the photo showing environmental destruction is rarely used in anything other than editorial spreads, images of wildlife and pristine forests are much desired by environmental steward organizations. These groups make many millions of dollars per year, with executive staff earning salaries that would be the envy of any photographer working today. We are each free to do what we wish with our images, but really question what you might gain by just entering and ultimately relinquishing any usage rights the image might have enjoyed in the future.

EQUIPMENT

"**S**kill in photography is acquired by practice and not by purchase." — Percy W. Harris

If alive today, Percy Harris would most certainly be amazed at how technology has advanced photography through its evolutionary phases; or would he? Regardless, his point remains valid. It matters not whether the stock photographer shoots with an 8 x 10 inch field camera or an iPhone loaded with the latest apps. The challenge for the photographer is to use what they have on hand and learn how their device reacts in all situations in order to pull the maximum from its capability. As Edward Steichen said: "No photographer is as good as the simplest camera."

What hasn't changed for the stock photographer is the basic premise that images must be made and delivered in the most efficient manner possible. The equipment utilized will most often be what is on hand. It would be very unwise to invest many tens of thousands of dollars in equipment if there wasn't a business case to warrant it.

THE LENS: It is important to recognize the lens is the single most significant ingredient in creating technically proficient images. Poor-quality lenses that are packaged in kits with entry-level amateur-grade cameras will generally suffice, but they usually generate a lot of artifacts and other deficiencies, such as image softness and color aberrations. If you must keep your equipment costs down, go with a lower-level camera and stick with pro-level lenses. There is no one lens that will satisfy all of the stock photographer's needs, so care must be taken when selecting focal lengths. A basic three-lens kit will cover most needs: 15–40mm, 40–110mm, and 100–400mm.

CAMERA: The first thing to recognize is that your camera bag should contain two cameras, and especially so if traveling to locations is involved. You don't want to be left without a backup if one should break.

↓
The importance of your lens

The quality of an image is more often than not a result of the lens quality. Should a decision have to be made whether to purchase a quality lens or camera body, opt to spend more on the lens.

↓

Instant imaging

Technology has advanced to such a degree with mobile devices that it can often be difficult to tell the origin of an image. In many cases the mobile image is of better quality than that of lower end DSLRs. Most agencies now have an app that encourages their contributors to shoot with mobile devices and upload "on the fly."

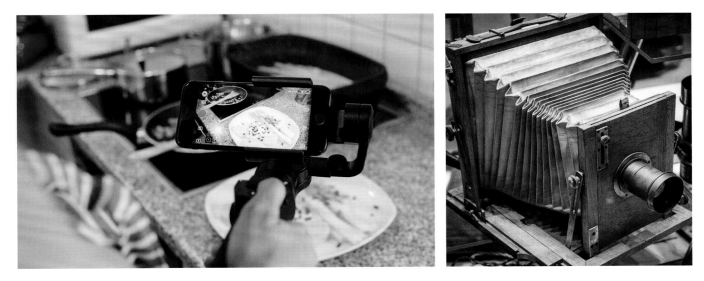

Most pro-level digital cameras have many hundreds of functions and menu items. Once the photographer gets their camera set up to satisfy a personal style, less than 10 percent of the total menu items available will ever be used on a shoot. Two things that should be given serious consideration are the sensor size and high-definition video capability. The sensor should be at least 20 megapixels in size, thus satisfying most agency submission requirements. Although there is beginning to be an oversupply in video footage, this deliverable also expands the revenue stream potential for the contributing photographer. Creating and delivering stock footage should be given serious consideration.

TRIPOD: Many see a tripod as an unnecessary piece of kit made redundant by raising the ISO to increase the shutter speed. Conversely, a good argument can be made for keeping the ISO as low as possible to reduce potential noise picked up by the sensor. Most importantly, a tripod will hold the camera stationary and facilitate good composition. A solid tripod and head costs money—expect to pay many hundreds of dollars. If a choice has to be made between a light, cheap aluminum tripod and hand-holding, defer to hand-holding.

With a good camera and pro-quality lenses in hand, the aspiring stock photographer has the essential tools of the trade. All that remains is to learn how to make a "working" photograph . . . those are the images that sell.

From a financial perspective, it is best to keep in mind that lenses can last many years if properly maintained and cared for. DSLRs, on the other hand, seem to be "new and improved" about every three years. ∎

↑

Technological advances

The camera is little more than a light-tight box within which is housed film or a sensor. While the 19th-century camera is perfectly capable of making exquisite quality images in the hands of a competent photographer, it is hardly efficient in today's high-volume stock industry.

THE DIGITAL DARKROOM

Image vault

You should consider archiving one set of either the original Raw files or the completed TIF files in a secure offsite setting. The files are your currency, and must be treated and saved as such.

n order for photographers, editors, and clients to all work in perfect harmony, each must be singing from the same song sheet. Fortunately, standards have evolved over time; subscribing to these standards ensures each person in the workflow viewing a photo will see it as the photographer intended.

WORKSPACE: The vast, vast majority of time a photographer spends pursuing their craft is in front of a computer monitor. Consequently, the workspace must be comfortable, possess good air quality, and have a desk and chair that are ergonomically appropriate to body type. Most medical professionals will also advise you not to get too comfortable, and suggest getting out of the chair and walking around for 5 minutes at 30 minute intervals. Beyond

personal well-being, these reprieves also improve mental acuity—looking at a monitor from afar will often enhance the creative process by helping you to see the bigger picture.

The ideal color and intensity of ambient light within a room has been identified and published as catalog number ISO 3664:2009, also described as Graphic Technology and Photography Viewing Conditions. Ideally, the ambient illumination should be less than 32 lux, and the area surrounding the monitor should be less than 3 percent of the monitor's white luminance.

COMPUTER: The computer is both the brains and lifeblood of the digital workflow. Whether the computer is a Mac or Windows-based platform is a matter of personal

choice. The higher-end Mac platforms are typically designed and built with visual content providers being the primary market, while the PC platform has a broader appeal to many different user types. The components of the machine should be selected with care, with particular attention paid to the graphics card and processing speed. Most professionals that are working on PC and Windows-based systems will have their machines custom built to heighten the capabilities above what is available from most off-the-shelf machines.

One of the most convenient designs for the computer workstation is a dual monitor system. Having two monitors side by side allows one monitor to be used exclusively for displaying images without distraction. The second monitor hosts all of the palettes, menus, filters, and other sundry items that can clutter a screen. With this setup, only the display monitor needs to be large and of superb quality, so you could potentially save money on the second. The physical dimension is also a matter of personal choice, with screens of 20 to 30 inches at resolutions of 2,560 pixels seeming to be most popular.

This larger monitor will also need to be calibrated on a regular basis—typically every two weeks. Some good-quality monitors come with a proprietary calibration kit, such

as the NEC line that includes SpectraView II. Another popular calibration system is offered under the brand name Spyder. Although you will need to consult your image agency, the standard color space used in stock photography is Adobe (1998) RGB.

SOFTWARE: Adobe Lightroom and Photoshop are the essential software packages required to manage your workflow. These are industry standard, and as such ensure compatability with clients and agencies.

IMAGE STORAGE: Think redundancy. Many books have been written on the topic of DAM—Digital Asset Management—and should be consulted. Individual situations will determine how much to spend on RAID V, cloud backups, or whether to simply use external hard drives to back up copies of Raw files and completed files. Regardless of the library and archive system employed, redundancy is of paramount importance. The cautious photographer will also duplicate the complete Raw shoot as well as the submitted files and save the copies in a safe offsite location. ■

↖

Calibrate for color

Every monitor will see color in a different light. When a designer receives a file for a print project, it will have to be converted to a CMYK color space as directed by the printer. Should the RGB file being supplied by the photographer not conform to an accepted industry-wide standard, the final CMYK file will most assuredly not be compatible with the photographer's vision. Should the file fall out of gamut, there is a very good possibility the designer—the person paying for the use of the image—will reject the image, and as a result, the photographer will lose a sale.

↑

Calibrating monitors

There are several devices and applicable software packages that will allow the photographer to maintain a calibrated workflow. Most manufacturers recommend calibrating the monitors at least once a month and recognizing that a monitor will have an average lifespan of 30,000 hours.

STUDIO

As more and more photographers enter the stock photography industry, the volume of images that are introduced to the marketplace each year increases proportionately. These volumes are staggering, measuring well into the many millions, and growing exponentially. As a result, the stock photograph has been commoditized, and, as such, the price per image has declined due to an oversupply in the market. Consequently, the stock photographer of 2020 has to work much smarter and much harder than their counterpart of just 20, or even five, years earlier.

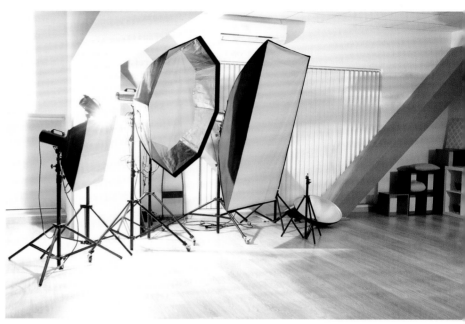

In light of all this, economy becomes paramount. One of the most economical ways to produce images is in the family home and local neighborhood. There is a growing trend for more natural pictures of people that do not have the model look. With that being the case, it should stand to reason the modern home could be the backdrop for making those images, and much more economically favorable than renting studio space and paying for all that overhead.

When making images in a studio or on location, there are a lot of bells and whistles that can be purchased to make the photographer's job much simpler. However, consider these as *nice to have* and not as *need to have*. The one thing that can't be overlooked, though, are lights. The type of light and how many is a topic open for debate, but a basic lighting kit should include four medium-powered heads.

While one photographer may prefer continuous lights, another may prefer strobes, another may prefer power packs, and finally, another contemporary may prefer mono blocks. There really is no definitive consensus. One thing is certain however: purchase four heads and learn how to use just one as the main light—the others should be used as fill lights to keep shadows from going black.

There are a lot of different light modifiers on the market as well. While these are nice to have, and certainly make life easier, they are not necessary. Most homes have white ceilings, and the home studio should as well. Bearing in mind the client wants natural-looking images, just point the flash heads

↑
Renting studios

Most cities will have studio rental facilities that are fully equipped. The more equipment that is rented, the higher the rental fee will become. A tax advantage to renting, in most countries, is the ability to claim 100 percent of the rental cost as a business expense.

↓
Home studio

With a little ingenuity and creative problem-solving, it is possible to make pictures right in the family home. In many instances, clients prefer the "slice of life" look that can be captured at home with an iPhone.

upward and use the white ceiling as a big reflector board, creating an even and full natural illumination.

There may be occasions when a fully fledged studio may be needed, such as when shooting a series of models against a screen to be later composited with different backgrounds. Should this be the case there are several options, the most logical being the renting of an existing studio.

Rental studios are found in many major cities and come in a variety of sizes with a variety of services offered. These facilities can get on the expensive side for the photographer shooting microstock, so it is necessary to study the numbers pretty closely to ensure the financial reward warrants the production rental costs.

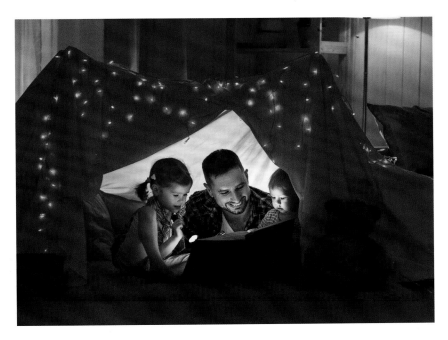

Another option for rental space is to befriend the manager of a local furniture store. Most stores have modern displays showcasing the latest trends in homeware and furniture. While it may take several chats over coffee with the store manager to work out a mutually agreeable solution, the prospect of extra money coming into the store's coffers with minimal cost should get attention. You should anticipate working at night when the store is closed, and hiring a staff member to work overtime to ensure safety and security.

←
Store displays

Displays at furniture stores provide an ideal studio set ready to shoot. The furniture and props will be current and complementary. The challenge is to convince the store manager it is worth their while to rent the display for a photo shoot. Expect to show proof of insurance in the event of damage, and to work during hours when the store is closed.

The bottom line with studio space is to watch the bottom line—do not purchase equipment until it is needed. By being creative and adventuresome, it is quite amazing how many alternative studio solutions are present right in your home and neighborhood. ■

STOCK WEBSITES & PORTALS OF THE FUTURE

Do you need a website?

Should the plan be only to get a few images on a microstock site and try to earn some beer money, there is absolutely no need to have a website incurring the cost and maintenance it requires. If going indie, huge resources will have to be invested into having an effective and efficient delivery platform.

Reality check number one: Photo researchers don't care what your name is.

Reality check number two: Photo researchers will not stroke a photographer's ego.

Reality check number three: Photo researchers want to find the right image in as little time as possible.

Reality check number four: Although it is very difficult to determine the actual figures, the research firm Deloitte predicted 2.5 trillion photos would be shared or stored online in 2016, a 15 percent increase above their 2015 predictions.

Reality check number five: Refer to reality check number three.

Should the entry level stock photographer merely want to make photos as a hobby to try to earn a few bucks on the side, then submitting to a microstock agency might be the practical choice. Bear in mind, those few images will be competing with billions upon billions of similar images. Again, refer to reality check number three. As a consequence of reality check number one, there is absolutely no reason for a website . . . notwithstanding the desire to caress one's ego.

Advertising creative departments and photo researchers spend an incredible amount of time pouring over many millions of mediocre photographs searching for the

correct image to incorporate into a campaign proposal. The time spent doing that research not only erodes the profit margin of the advertising firm, it potentially reduces the markups most advertising firms charge to their clients.

By that logic, one way to maximize the photographer's revenue would be to increase the ad agency's revenue by decreasing their labor costs. But how could the labor costs be reduced? One answer may lie in the image search portal itself. When the stock image portal improves the photo researchers' efficiency, the researcher will make that site their first stop. Research also indicates the site must show the "correct" image within the first 100 images, or that researcher will be moving to a competing website.

How to build that perfect site is best left to the experts: graphic designers, computer engineers, e-commerce facilitators, back-end support staff, and so on. The most important task will be that of the search engine optimization and new media personnel that will have to brand, market, and sell the site. While all of these experts are applying their skills to make the site intuitive, friendly, visually appealing, and functional, the photographer is best to take the advice of most successful entrepreneurs: Hire people that are more skilled than yourself and provide them with the means and tools to do their jobs. If you hire the right people, you will have a website that is effective in reaching its audience and promoting the images you populate the site with.

How to populate the site with images will be one of the most difficult issues that will have to be addressed. It is highly unlikely there

exists a photographer that can fulfill all image types with top-shelf material, and you don't want to showcase mediocre images as that is how your site will be remembered. Consequently, you may want to consider recruiting like-minded photographers to join your venture, covering as many image genres as possible. In essence, you will become their stock agent, or you can form a cooperative following the Stocksy model.

There is a certain logic to having 100 of the world's best genre-specific stock photographers populating one portal with only 500 tightly curated images in the collection. The images must be of the type and style the researchers are seeking; otherwise they will click out of your site. The site must also be one of quality and not quantity, thus decreasing the researcher's time, which ultimately saves money through increased efficiency. When the client makes money, the website will make money by way of capturing market share. Quality must be the driving factor as you simply won't be able to compete with the mainstream agencies in budget-priced microstock.

The future of stock websites will be twofold: the ultra large microstock portals that work on massive volume, and the very tightly curated royalty-free purveyor that charges a premium for their offering. ∎

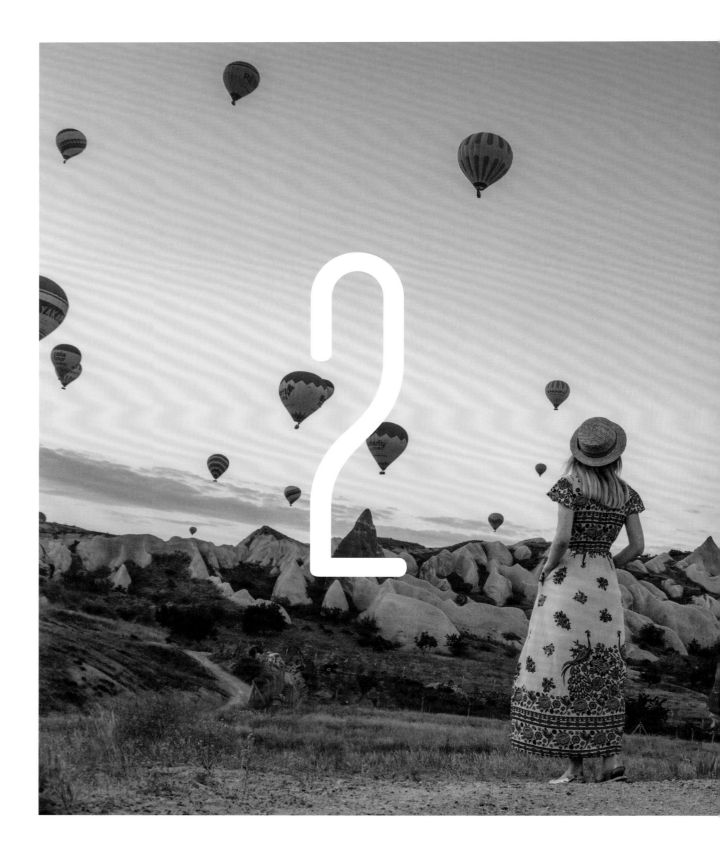

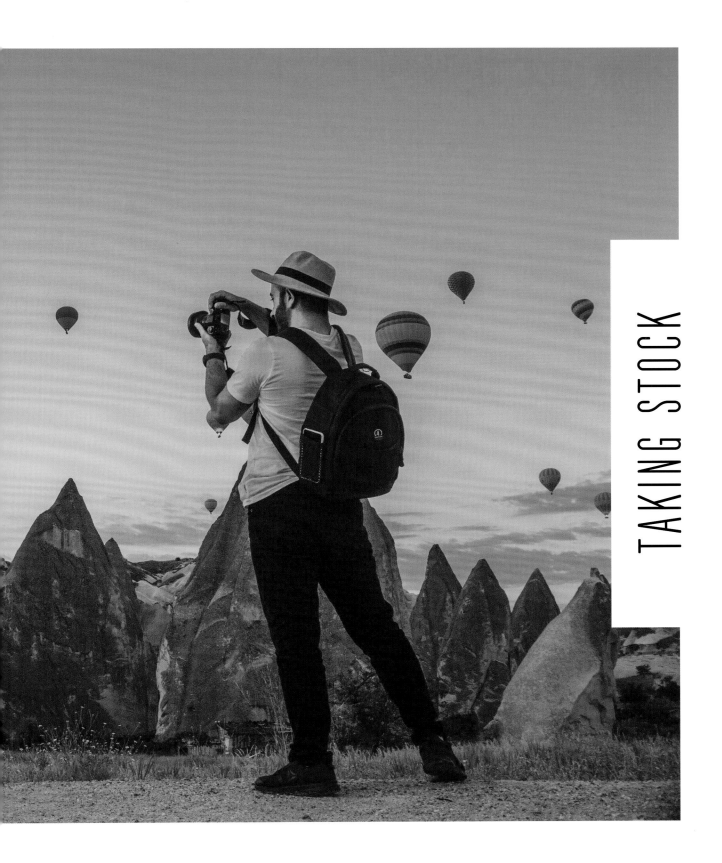

TAKING STOCK

RESEARCHING YOUR SHOOT

Regardless of whether you have signed a contract with an agency or decided to go indie, the fun work is about to begin—creating content for the collection. But, what to shoot? The answer is quite simple, yet it can be complex and challenging to get it right: Shoot what you know, but do it better than anyone.

John Lennon once reworked a T. S. Eliot quote and said: "amateurs borrow, professionals steal." Few words could be closer to the truth. With almost one billion photographs available for license at the time of writing, it is a reasonably secure bet that the shoot you're planning has already been done.

In addition, the beginner stock photographer must also accept the fact that should they introduce a never-before-seen concept, it will only be a matter of months before a sea of take-offs and rip-offs start competing with the hard-earned original work. Ultimately, it's possible to assert your copyright in the work, but not in the idea, so, should your idea be copied, move on and focus on creating more compelling and refreshing work. Accept that your ideas will be ripped-off; be professional and use these instances as motivation to generate more original content.

One basic premise that should ring loud and clear is that people sell. It matters not if the subject comes under landscape, travel, industrial, or any of the other myriad image categories, pictures with people included will outsell a similar image that does not include people.

When thinking of people and backgrounds, it is imperative to consider ethnicity, religion, gender, and age. Find a fresh and

Understanding the moment

Advertising to the LGBTQ2 community is advancing rapidly and good working images are in demand. This is a great example, the wardrobe is neutral and it's taken from a nice camera angle. Look out for background distractions: the turn signal is growing from the model's head.

Double the potential

Look for ways to maximize sales opportunities. This image is a great example of two ladies that could be used for advertising targeting the LGBTQ2 community or just profiling non-Caucasian friends. Make sure the ethnic origins of the models are identified and that they have signed a release. Care must be taken with accessories; it is usually best to not include jewelry as the style could date the image..

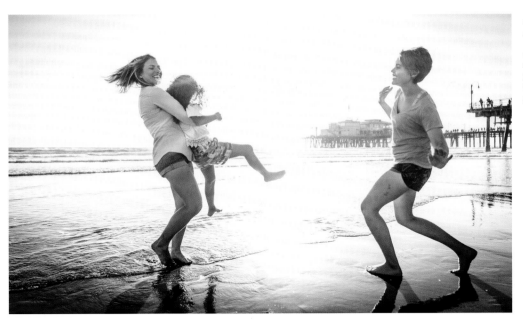

←
The new modern family
All of the family lifestyle images that apply to a "straight" family also apply to LGBTQ2 families. This creates a huge opportunity due to less competition within the agency files.

previously unseen way to portray visible minorities and differing family lifestyles such as multiracial and LGBTQ2. Equally important is to have a working knowledge of where geographically the majority of your total sales are made, who are the dominant advertisers and media outlets that use stock photography, and what are the visual and copywriting styles that tend to be utilized most? Only by understanding everything you can about potential clients can you target your shoots.

It is imperative to know what already exists in stock agency collections and potential competing image collectives, such as free government source libraries. Shutterstock is a great location to start that research; not only are they the largest microstock agency in the world, it is also easy to tell how many images they have in each category as the search is narrowed.

For example, in early 2018, the search for *people* reveals 23,056,716 images. By searching for *people, Asian* the return was 2,284,010 images; that is still a lot of pictures, but only 10 percent of the total people collection. Should the word *gay* now be added, there

are only 1,013 images in the collection. Next add the word *female* and in just a few minutes it can quickly be determined that the largest microstock agency in the world only has 152 images of gay Asian women.

Many experienced photo researchers will typically only look at three web pages or 100 images on a specific site. If they haven't found the image they are seeking in that amount of time, they will move on to the next site. Consequently, should the photographer wish to earn an income, it is necessary to place images where there is the least amount of competition, providing that subject matter is in demand.

Simply select an idea and starting working that idea through an agency search engine to learn what similar images exist. Very quickly it can be determined if that category is saturated with existing material or an opportunity might exist to fill a void by shooting variations and subgenres.

To answer the original question, shoot what is enjoyable, but do it better and differently than everyone else. Most importantly, shoot with a purpose. ∎

DESIGNING A SHOOT

"Shoot with a purpose"

..

s the mantra of the stock photographer. To be successful, stock photographers must become experts in risk mitigation by shooting what will be in demand next month, not what was in demand last week.

The old catchphrase used to be "shoot vertical and leave lots of room for copy" when the majority of photos would be used in print. However, more and more content is now published via web-based media in a horizontal format. Although very much anecdotal, a review of recent sales statements revealed that approximately 65 percent of image sales in the third quarter of 2017 were for internet use. Recognizing this, the photographer's work is now best presented in a horizontal (landscape) format; with the vertical (portrait) format being of secondary importance.

There is a cost associated with every shoot, if not material then in time—and time is the most valuable commodity in every project. To get the most from the time available, it is imperative to enter the shoot with a purpose and a schedule. A checklist within hand's reach is always a good approach to ensure your objectives are achieved. Many photographers will also attach a sketch or sample photos to the checklist to provide visual reference to ensure nothing is missed.

There are five broad categories that describe the types of images you should aim to capture when designing a shoot:

1. Environment—this is a broad overview of the location being photographed with no talent on set (think wide-angle lens).

2. Environment and Activity—this remains a wide-angle scene with talent moved into the set, creating a big scene and small people.

3. Activity—the focal length has changed and shows the talent engaged in the activity (think long lens).

4. Detail—again the focal length changes and the activity becomes the dominant aspect of the image (think macro or close-up).

5. Portrait—always do portraits of the talent where the faces are dominant and the activity (if shown at all) is secondary.

Experience has shown that it is most efficient to start designing the shoot with just one or two models in mind; otherwise the production quickly grows in scale and will require staff in order to keep everything moving fluidly and efficiently. As the skill of the photographer and production staff grows, so too can the scale of a shoot.

The objective of any shoot should be to get as many great images as possible within each category. You can alternate the camera perspective by shooting low and high, but

→

The importance of props

By changing props, the photographer is able to capture the same scene that could be marketed at clients in two different fields: business and communications. Care must be taken with prop selection however—laptop computers have recently given way to tablet devices and as a consequence the image is now dated and would most likely be passed over.

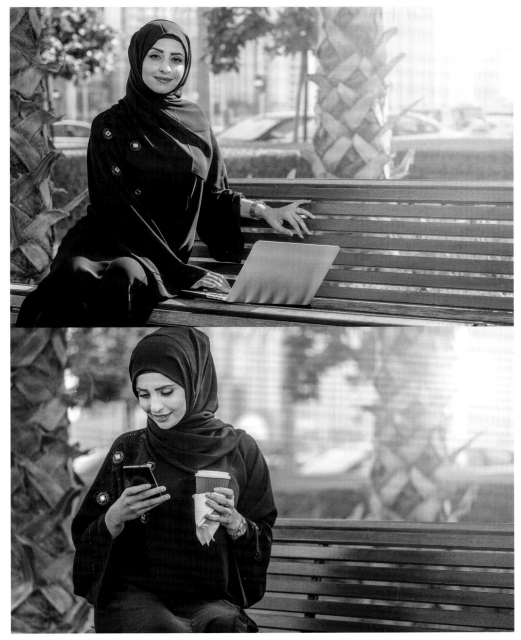

also by changing angles. Is it possible to place an object—perhaps a large plant—in the foreground and entirely change the scene? Try changing the lighting situation, or you could explore shooting high key (light and airy) and low key (dark and moody), particularly when doing portraits. Incidentally, high-key imagery tends to sell better than low key, at least at the time of writing.

When the models are brought onto the set, wardrobe changes can be introduced to reflect different seasons and styles specific to different geographic locations. Likewise, with set propping and design, by swapping the morning fruit on a coffee table to an evening wine and cheese tray, and with the model changing wardrobe,

it is possible to have a completely new scene to photograph.

Maximize the opportunities for different shots and shoot with a purpose. Stock photography is work, and the results of the shoot are directly proportional to the effort put into pre-shoot production. ∎

↖
Consider your angle

Most likely the photographer simply stayed in this little green space park and turned the camera in a different direction to change the background. By using a lower camera angle it also places the woman in a higher position of authority, which is good for business applications.

↑
Cover all bases

The photographer was able to capture 363 images of this one model. By having a systematic strategy using the "five category" approach, an even more diverse collection could have been created, generating more sales potential as a result.

		DATE:
Lead Photographer: 2nd Camera: Creative Director: Art Director: Production Manager: Photo Assistant 1: Photo Assistant 2: Casting:	**CORPORATE LOGO** **Stills Photo Shoot**	

WEATHER:	**CALL TIME** Check grid for talent call times	HEALTH & SAFETY: First Aid: Emergency Call: 911 Nearest Hospital: Poison Control: 911 First Aid kit and fire extinguisher on set at all times

#	Location	Address
1		
2		

#	Scene and description	Talent on set
1		
2		

#	Talent	Role	Call time	
1				
2				
3				

Notes / Miscellaneous

Set requirements
Props:
Special Effects:
Child Wrangler:
Wardrobe:
Makeup:
Set Designer:
Lighting / Electrician:
Kraft Services / Times

↓

Drone photography

Due to safety and privacy concerns, many countries have legislation that requires UAV pilots to have a license. As a result, many agencies only accept images when the photographer clearly identifies as having met the requirements. Stock photography is considered commercial, thus eliminating the recreational statutes.

CONTENT RESTRICTIONS

One of the hottest ancillary devices in both video and still production since about 2015 has been the drone, or more accurately, the Unmanned Aerial Vehicle (UAV). Once the territory of high-budget shoots involving helicopter and fixed-wing aircraft rental, the UAV has allowed photographers to reach into the sky. But can the results be utilized as stock photos?

Well, it depends on (please excuse my Canadian hockey metaphor) a hockey sock full of variables—which means there are a lot of them. Firstly, images made from a UAV shoot for personal use are not considered commercially produced. If, however, the same images are placed with an agency, or otherwise made available for licensing, they are deemed to be commercial images. Each respective country will have regulations determining whether or not a recreational UAV can be utilized unfettered in the production of commercial images.

Australia, Canada, New Zealand, the United Kingdom, and the United States (and likely other countries as well) require the pilot to be formally trained, resulting in a license, and in many cases have certification similar to that of the private fixed-wing aircraft pilot. As one can imagine, this becomes a very expensive and time-consuming proposition. Because of these restrictions, most agencies will not knowingly accept the images and footage produced from UAV flights unless the regulations have been met and are embedded into the metadata of the submitted images.

The same restrictions apply should the photographer be representing their own work as opposed to licensing it through an agency. If licensing images as an independent, bear in mind the old proverb "the proof is in the pudding." As the purveyor of that material, the photographer is ultimately responsible, and there is no more damning evidence benefitting the constabulary than a page of low-altitude aerial images on a public website.

There are also many other restrictions the photographer has to be aware of. For example, urban art, street art, and graffiti are all protected by the same copyright laws as those which protect our photographs. Considerable care must be taken when making images with visible street art, even if it is in the background. The courts are ruling in favor of the graffiti artist, and as such it is recommended to avoid including such scenes in commercial stock photos. Even for editorial shoots you should be mindful of this restriction, and if at all possible, move to another location.

The same caution should also be observed when including designer furniture, public

buildings, and other art forms such as sculpture and public art installations.

Even certain cars and travel trailers (caravans) can be an issue. In the United States, the Airstream travel trailer has a very unique and identifiable design. The design of the actual vehicle is trademarked; not just the identifying brand signage, but the physical shape of the trailer. Consequently, even the owner of an Airstream trailer cannot authorize its photographic reproduction by way of a property release. There are many other examples.

Most photographers are aware of the wise adage to not show any signs or brand labels in a stock shot, but the reach can be far greater. The photographer must be aware of the restrictions and do everything within their control to mitigate those risks. Even with the greatest care and diligence, mistakes can be made; third-party intellectual property claims are one of the primary reasons to carry private insurance. ■

Street art

Just as photographs are protected by copyright, so too are public art installations and street art. As a result, property releases—and in this case a model release as well—are required for the commercial use of such images.

Monuments

Images of the Eiffel Tower could be subject to copyright restrictions, and as such could require a property release, depending upon the time of day: for example, the light show at night is subject to copyright restrictions. Photographers must be aware of potential restrictions and keep up to date with any changes.

FINDING THE RIGHT LOCATION

Stock photographers have to be resourceful and should always be mindful of their surroundings. We must continuously make mental notes for future reference—should a location really pique our interest and get the creative juices flowing, fire a few shots with a mobile phone and record notes. Be particularly diligent in noting the direction and angle of the sun at the given time of day. Depending on the latitude of the location, the season will also have a direct influence on the direction of the sun, and particularly so when it's at the low angles of sunrise and sunset.

The photography industry can learn a lot from the film industry and should take pages from their play book. There is a reason the film industry employs location scouts. These are the folks that have mentally recorded every unique and not-so-unique, interesting and not-so-interesting, accessible, and promising location within their region. They make relevant notes about each location and, most importantly, make contact with the person who has the authority to grant permission for its use in a film. This has to be the individual that can authorize a photo shoot to proceed and sign the property release. The photographer may have to exercise some due diligence and use common sense in this respect. For example, a security guard does not have the authority to sign the property release—it is best to have the property owner or, at minimum, a member of the property management team.

Should the desired site be an internal location, such as an apartment complex, there are certain questions that must be asked. Experienced location scouts will have a checklist to prompt them and will record the answers as the location may not be used for some time and memories do fade. The questions include: Is there sufficient power capability to run lighting equipment? Are there restroom facilities? Are there windows and what direction are they facing? What is the ceiling height, and color (it's easy to bounce light off white ceilings)? Are there kitchen facilities that can be used by a food stylist or catering service? If shooting video, what is the ambient noise? Is there building security for both the equipment and staff? And there will be many other incidental details to record that might appear relevant at the time of scouting.

↓

Adjustable backdrops

This grand staircase would make a great backdrop for many different photographs. With creative propping and the right posing of a model, the staircase becomes a perfect location for the Victorian woman opposite. Technology now allows us to take the location to the model in the event we can't take the model to the location.

↑
Iconic locations

The iconic Times Square in New York has a photo policy in place and working there may require a permit from the city. This image, made by Songquan Deng, can only be used for editorial purposes. Do you know why?

↗
Consider your setup

The metadata attached to this image suggests the model is a Victorian lady, however, the wallpaper and table linen are not from this era, neither is the jewelry. Most importantly, however, no Victorian lady would ever sit with this pose.

When working in public spaces, the same questions have to be addressed with the appropriate additions or deletions. Most importantly, public spaces are typically under the authority of a governmental department, and that means there is usually a photography or film production policy in place. For the independent stock photographer, public spaces are often avoided due to the heavy administrative burden of securing their release. But if you learn the policy and leave enough time in advance of any shoot, such locations can provide iconic backgrounds that are difficult to substitute.

Regardless of where the shoot takes place, always think of the next production. It is critically important the location be cleaned and tidied up when the shoot wraps. A good habit is to always leave some little token behind as a gesture of thanks, independent of any location fee that might have been paid. If a private condo, for example, a nice big bouquet of flowers will long be remembered. The staff at an industrial site might enjoy a donation to their coffee fund. Are these gestures necessary? No. But they sure do go a long way, and you'll be remembered in a positive light the next time you might want to work at that location. ■

↑
Staging your images

In comparison to the previous Victorian lady, this model is more like a stage performer photographed on set in a theater. The hair, makeup, wardrobe, and accessories are all within the correct time period. It is also interesting to note the setting is a combination of a painted backdrop and physical props, all enhanced with creative lighting. To enhance our creative repertoire it is advisable to become a student of the various performing and visual arts—we can learn much through observation.

LOCATION CHECKLIST

Project Title: Property Address:

Date:

Contact: Contact Tel

Can contact sign Property Release Y / N

DETAILS

☐ Permit(s)

☐ Location fees

☐ Fees, Detail

☐ Natural Light

☐ Electricity (amps)

☐ Water

☐ Dressing / Rest Area

☐ Parking

☐ Stairs/Elevators/Door Width

☐ Security

☐ Access (after hours)

☐ Bathrooms

☐ Catering/Kitchen

☐ Public Transit

PHOTOS

Attach photos amplifying check list, and primary areas of interest or concern.
Ensure each photo has north orientation.

PROPPING FOR A SHOOT

When a location is not appropriately propped, it is akin to having a model wear polyester bell-bottom trousers and a yellow-and-purple polka-dot tie. Just as we wouldn't utilize the "used-car salesman from the 1970s" look in a contemporary business shoot, neither should we prep a set without considering the suitability of the props. Poor-quality props or props from an incorrect time period will kill the picture's sales potential quicker than water droplets disappear in the Sahara.

Putting the right props into a scene can be expensive and most often cost prohibitive. Consequently, be careful and judicious when sourcing props.

Along with the considerations outlined in "Finding the Right Location," propping is one of the primary concerns when renting a condo, apartment, or furnished show home for a potential shoot. Most often the real estate agent or property manager will have these locations staged with the most contemporary, or appropriate, furniture and props in order to showcase the property in its best light. The photographer would do well to find a mutually beneficial arrangement to access these ready-to-shoot properties. This could be something as simple as a trade for service—however it is not something I would personally do, as trading services can potentially open up all

Updating props

Golf is a huge recreational pastime, and particularly so in America. This image did very well for the author for about four years until a new style of club head came on the scene, rendering this image outdated. Refreshing selling images with current props is essential.

manner of complications; it is much simpler to pay cash for a day's access.

Shooting still lifes gives you the opportunity to develop a style that is unique. Beyond being extremely difficult to execute well, still-life sets are also a lot of fun to build. Once the concept has been sketched out, it is time to start sourcing the props. This is the fun part.

It is possible to go scouring the many cupboards of the internet, but that takes away the fun and can get expensive pretty quickly. Turn your attention to local antique

and curio shops. If there are film and TV companies in your town, the antique shop owner will likely be well-versed with their rental policy. Usually, the photographer will pay full price to purchase an antique prop. After a pre-arranged time, when the shoot is completed, the photographer returns the antique with the bill of sale and is typically provided with a 60–75 percent refund of the purchase price. In other words, if that antique was initially $200 at retail, you can rent it for around $50 for a week.

Renting props for still life shoots is a win-win situation: the photographer gets a quality prop for a fraction of the retail cost, and the store owner gets some added revenue from an item that might otherwise be sitting on a shelf collecting dust. By building a rapport with the shop owner, and respecting the fact that you need their services and goods more so than they need yours, it is quite possible to develop a friendly business relationship that can provide dividends for both of you over many years.

Care must be taken when designing a shoot to ensure the sales potential of an image is not limited by dating it with a mix of props that are not consistent. By staying within a theme and time period—and being consistent with the lighting style, set design, and prop choices—it is possible to produce saleable images and have a lot of fun in the process.

Of course it goes without saying, some props are just too nice to return to the antique store. ■

↑
Still life experiments

Few image styles embrace the use of props as much as the still life. This genre also presents a wonderful opportunity to practice the elements that create a good image, including well-chosen and well-placed props, but even more importantly, lighting.

→
Don't set the date

A wedding planner? This image sends mixed messages, but more importantly, its sales potential is restricted to just 2018. Specific dates should be avoided as they, well, date the image.

SUPPORT STAFF: HAIR, MAKEUP, & WARDROBE

Ask any successful business person what is their secret to success and they will most likely respond with "I surround myself with people that are better than me, pay them the best I can, and give them the tools to do their job well." To the independent stock photographer, no words and advice could be more applicable.

Just as the vast majority of makeup artists, hair stylists, and wardrobe designers are not photographers, neither are the vast majority of photographers experts in those supporting professions. Stock photographers should once again look at how the film industry conducts its business in these fields.

Makeup Artists: Fortunately, and thankfully, gone are the days when talent had to be made to look like Ken and Barbie dolls. Advertising agency creative directors instead began demanding the generic "next door" look, not models with painted on makeup and hair so stiff it could break in a soft wind. However, the relaxed look did not necessarily mean the support trades were now completely eliminated from a photo shoot—they just had to be more subtle.

If you watch the evening weather report closely, it will most likely be evident that . . . yes, the weatherman is wearing lipstick and has his face powdered to control reflected highlights from the lights.

Competent makeup artists know how to create the precise foundation to support powder that will warm the facial color without being obvious. Will you need lip gloss or lip coloring, or a combination of both? What about the eyes and any skin imperfections? An experienced makeup artist can give you the "girl next door" look without being obvious, and that should be the objective.

Hair stylists: Hair stylists do so much more than run around the talent pulling hair out of their eyes. Like the makeup artist, the hair stylist has a bag of tricks—most often secrets they refuse to share—that can bring your talent to life. If you plan on using soft light

↓
The girl next door
This is an example of a really well-executed and simple image that suggests "the girl next door." A competent wardrobe advisor would have made mention of the torn jeans and drawn attention to the fact that this trend-specific style shortens the shelf life of the image.

with a lot of modifiers, they will know what type of hair treatment to provide. Alternatively, if you plan on using hard light for creative effect, they might have to tone down the resulting specular highlights with dulling sprays. And the list continues.

The experienced hair stylist will also be aware of historical trends. Should you wish to have a series of Victorian-era images on file, obviously period-appropriate styling is imperative. Likewise, if "girl next door" is the desired look, a competent hair stylist will know what style will still look current in the next few years. Few things can kill the life expectancy of a stock image as definitively as a dated hairstyle, other than wardrobe.

Wardrobe: The wardrobe stylist's job is not about fashion, it is about wardrobe. Using the Victorian example again, the cut of the fabric and how it is stitched will have a direct bearing on whether it passes muster with a textile artist. They see things the photographer doesn't, and this is critical. Good wardrobe stylists know what clothing will have a long shelf life and cross international boundaries to give an image maximum sales potential—and that is what it's about.

Just like the successful business person, the photographer should surround themselves with professional support staff. You have to love people whose job it is to make us look good! ■

↑↑
Hair essentials

The tools of the trade of the on-set hair stylist. The hair stylist that has been trained to work in film and photography understands the nuances of light and how light can bring life and vibrancy to the model.

↑
Looking good

The makeup artist, hair stylist, and wardrobe stylist's sole purpose on a shoot is to make the photographer look good. The photographer needs only provide good direction, suggesting the desired look and feel, and the resources for the support staff to work their magic. When the support artists make their subject look good, they make the photographer look good; embrace that notion.

MODELS VERSUS TALENT

The photographer is the person standing behind the camera. In order for the photographer to be successful, they have to be more interested in the person in front of the lens than behind.

Most of us photographers are fortunate to live in cities and towns that have casting agencies and model agencies. There is a huge difference in how each of these agencies train and educate those they represent and it is incumbent upon the photographer to know the difference.

Model Agency: In a January 2016 article in Vogue magazine, Janelle Okwodu opines that the average age of a model still hovers around 17. Although somewhat older data, a 2011 survey among working female fashion models based in the United States conducted by the research data firm Statista found that 54.7 percent started working between the ages of 13–16 years old. By comparison, the same survey reported less than 7 percent started working when they were older than 21 years of age.

This data is relevant to understand how models are trained and groomed for their careers. At very young ages, these young women go to the model agency seeking fame, fortune, and front covers. The agency in turn will agree to represent the aspiring supermodels if they agree to be represented and trained by the agency at a cost to the model. By the time the vast, vast majority of aspiring models reach the age of 20, if they

←

A classic cowboy

An interesting and timeless shot of a rough-and-tumble Marlboro-esque man. The subject is most likely a trained actor, judging by the convincing steely expression, complemented with good wardrobe styling and lighting. This image would be an easy candidate for transposition into a suitable background for a variety of messaging options.

haven't become so already, they will most likely never be the next supermodel. Instead of magazine covers, most opportunities will be in catalog work at much lower pay. Very rarely do these models stick around beyond the age of 20, and even more rarely do they learn how to professionally perform beyond posing for the camera and walking the runway.

Talent Agency: The talent agency, sometimes called a casting agency, works much along the same lines as the model agency. The primary difference being how the talent is trained, and the roles they are

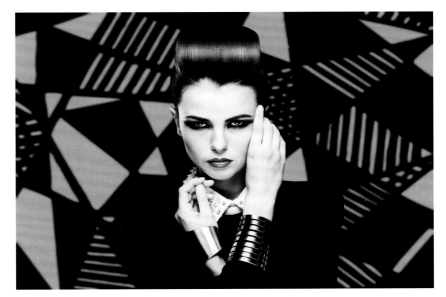

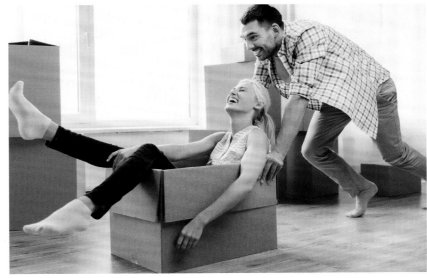

hoping to fill. The role of the talent agency is to train their charges to work in performing arts such as film, television, and to some extent the stage. This is where the aspiring actor can advance in leaps and bounds ahead of the model, insofar as potential work with the stock photographer is concerned.

A good actor can read an assignment sheet and understand very quickly the role of the character, and the emotion that should be portrayed. This is what photographers need to capture—character. A well-trained actor should be able to get into character with little direction.

Hiring talent for a shoot may appear to be an unnecessary expense, however when a professional—truly professional—actor walks onto your set, takes a quick scan of the surroundings, confirms where the main light is, looks to the side for a moment, and gets in character, you will know this is a professional that is going to make you look like a genius.

Hiring professional talent should not be seen as an added financial burden, but a necessary cost when developing the shoot budget. The investment good talent brings to a shoot will typically be more than offset by having selling material on the top shelf for a longer period of time than your competitors. The choice is there to be made: compete with the competition, or be the competition! ∎

↑↑
Fashion restrictions

High fashion shoots are most often conducted on assignment and have limited stock potential. It is possible such images could be licensed in the categories of health and beauty, hair, and jewelry; however, be aware that most advertisers in these genres will rarely use the high-fashion work of a competitor to showcase their own talents.

↑
Effortless talent

An example of a classic stock photograph of actors having fun while moving into their new home. The talent is oblivious to the camera and lighting setup, and are relaxed and in character. This a great stock image that can be used in editorial or advertising in both print and digital media.

FILE FORMATS & THAT DAM PROCESS

That DAM (Digital Asset Management) protocol starts with a single word—Raw. Shoot only in Raw.

The Raw format produces a non-compressed file that can always be accessed in its original state, as recorded directly by the sensor and lacking onboard processing. Providing the original file is retained, it is always possible to "season to taste" the image at a later time as no permanent adjustments or corrections have been made to the original during the processing stage. By comparison, if the photographer works in JPEG, each time the image is opened and saved the file loses data through the compression process inherent in the JPEG format. Therefore, it is a more efficient file management system to work in Raw, and then save the image in a secondary format as required.

A second reason to work in Raw is due to algorithm advances in processing software. Should you have underexposed images—which are otherwise good compositions—from just ten years previous, it is an interesting exercise to open those Raw files using the current and most recent versions of processing software, such as Lightroom or Aperture. The improvements should be particularly noticeable in the highlight and shadow detail that can now be extracted. The data always existed in the Raw file, the processing software simply didn't have the capacity a decade ago, or more, to extract what we can now see. Being aware that algorithms will continuously improve, the

↑
Cloud storage
Keeping the original Raw files in an off-site location or uploading them to a cloud service provides piece of mind by adding a level of image security.

prudent photographer must always have a mind to the future: Images that are not technically acceptable today could very well be quite usable with a few future software upgrades.

The elephant in the room is the DNG format. In the first decade of the 2000s, there was much discussion about Raw being a proprietary format. In other words, the photographer had to use the manufacturer's processing software or a software service provider—such as Adobe—that had licensed the algorithms from the developer (think of the file extensions .CR2 for Canon and .NEF for Nikon, as examples). Adobe responded to the concern by developing an open-source file format called DNG (Digital Negative). Initially many photographers embraced this new format thinking camera manufacturers

↓

Advancing technology

While post production software
continues to advance, the ones and
zeros of an image's binary code don't
change. Consequently, new subtleties
could be revealed in a photograph
made just a short decade ago as
software algorithms advance.

would develop cameras to produce the DNG
as a native file and eliminate their respective
file extensions. This hasn't happened, with
only a very few exceptions.

There is also debate around whether saving
a file as a DNG, as opposed to Raw, is as
advantageous as originally believed. There
are downsides to the DNG format including
increased processing time, loss of original
metadata, and doubts as to whether the DNG
really does save storage space.

Personally, I no longer process files in my
workflow as DNGs. Raw continues to be a
proven commodity, and with the big camera
manufacturers not embracing the open-
source DNG, there is very little risk of future
incompatibility—manufacturers will
continue to support their respective formats

and Adobe will be required to license those
algorithms in order to stay in business.

Every photographer will have to come to
their own conclusions about how best to
manage and archive their files. However,
most experts will agree file redundancy
is critical. To use an oft-stated military
metaphor, back up your backup. Many books
have been written on the topic of DAM, and
it would benefit the stock photographer to
have a working knowledge of the subject.
How you proceed with cataloging and
migrating your images over time will
depend very much on how the DAM
archival catalog has been established.

The one consistent opinion among the vast
majority of professional stock photographers
is to continue shooting in Raw. ∎

↑

Archiving images

The elephant in the room is
the Digital Negative, or DNG file.
Once heralded as the standard file
extension camera manufacturers
would embrace, time has shown
that not only are manufacturers
hesitant, the file itself may not
be as efficient first believed.

COLOR PSYCHOLOGY

"Color is to photography what verbs are to writing."
Daryl Benson

..

From the day we are born we start to see the world in color. Just like taxes and death, there is no avoiding it, or at least we should hope not.

If a verb is defined as the action word, then how can a specific color be an action color? This very much depends on how much color enhancement, and what means of introduction—be that via saturation, HDR manipulation, or filters, as examples—one infuses into the image.

Advertising agencies make it their business to understand the psychology of color and the impact their choices might have. Imagine just for a moment you are a parent of a young three-year-old child. In your mail you have just received two adverts from a pre-school soliciting your business and why their place of business would be best suited

to your child. One brochure has brown as a base color with beige accents and black text. The other has blue as the base color with orange accents a darker shade of blue as text. Without even reading the text, which brochure are you considering first? This is the influence color has in advertising.

In a research paper for the University of Winnipeg, Canada, Dr. Satyendra Singh writes, "People make up their minds within 90 seconds of their initial interactions with either people or products. About 62–90 percent of the assessment is based on colors alone." It should therefore only stand to reason an astute photographer should have a working knowledge of color psychology, and especially so when developing still-life images where they have full control of all the elements within the image.

There are five primary colors used in almost everything we produce and design: blue, red, green, white, and black. From these primary

Color popping

Against the black background the red stands out and offers an illusion of brilliance and strength. When bordered by green the same intensity of red comes to life and it is vibrant and happy. By comparison, when surrounded by orange there is no contrast and the red square appears quite bland. Introduce violet as a neighbor and it simply kills that once vibrant and full of life little red square. Understanding how colors complement or distract from one another will help you create images with more impact.

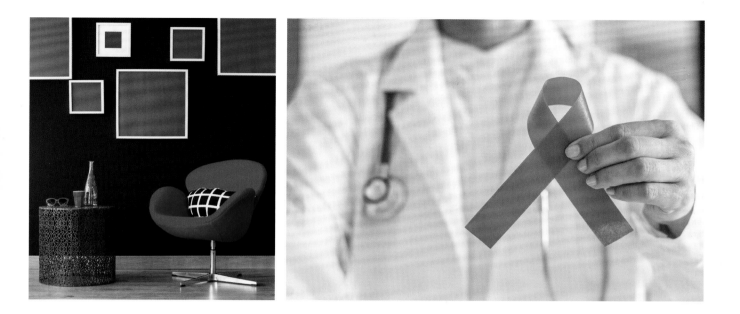

colors all of the secondary colors and hues are derived. Putting aside the color wheel and color theory, in terms of color psychology, the primary colors have the following associations:

Blue, and its derivatives, is one of the most popular and widely used colors of all. Not only does it seem cold, pure, and clean, it also suggests the notion of honesty, stability, and dependability. It is most often used in the medical and financial sectors.

Red is the second most popular color. Red can also send a mixed message as it is universally considered as a warning or stop color—a real attention grabber—but it is also considered a hot color and signifies action with boldness. Orange is a derivative of red and is popular with designers to provide a similar impact to red but with less harshness.

Green is often associated with health and wellness and is most popular in

environmental messaging such as on the subject of global warming.

Black and white are most commonly utilized for type, depending upon the background. Despite the perceived starkness of black, creative designers will also use this color as the dominant color on campaigns to show wealth, prestige, and privilege. A high-gloss black with silver text and spot varnish exudes confidence, stability, and money.

A great resource to stay abreast of color trends and forecasts can be found by reviewing the data provided by the expert authorities at Pantone.

Whether or not the stock photographer should be a student of color psychology is a matter for debate. But one thing is certain, it is designers who will be licensing the images, and they are students of color. ∎

The power of red

Red is a strong bold colour that makes a statement. It can help draw attention to text or products.

The reassurance of blue

Blue is a natural complement to the pure and clean whites used in the medical field.

COMPOSITION

There is a fallacy among many inexperienced stock photographers that lots of sky has to be included in the picture in order to place type. In fact, that depends: How will that picture be used? Interior images in books rarely have type set on top of an image, nor do wall calendars for retail and advertising. This notion comes from the early days of stock photography when the images were largely used for editorial purposes, and more specifically, magazines, as they tended to pay better.

However, in advertising, there are many examples where an image may or may not have type dropped in. It often depends upon the designer's flavor of the day. Should they be aiming for a "clean and pure" message, for example, they most likely will not superimpose text. If the message is one of chaos and action, there is a strong likelihood a lot of text could be dropped in.

According to Ad Age Datacenter, digital advertising, unsurprisingly, has doubled since 2009. But growth is starting to slow, with a modest 7 percent increase in 2017. The analysis the photographer can take from this one report is that their images are more than likely to be used in non-paper advertising. While the growth appears healthy for the agency, it should be noted by the photographer that digital advertising returns a smaller license fee than print.

Since digital advertising has surpassed traditional print as the media of choice,

photographers should be aware that portrait format is no longer the preferred orientation. Digital media is primarily seen on computer screens, televisions, and electronic billboards—all are landscape or horizontal in format.

Just as life is not always simple, neither is being a stock photographer. While it can be said that more than 50 percent of all advertising is delivered in digital media, the market researchers Statista indicate that 34.5 percent of the digital advertising in 2017 was onboard social media platforms. If you review social media advertising, it's apparent that many of the images used are on banners or in a square format.

So what does all this mean?

While not wanting to suggest you should be a slave to the analytics, stock photographers should use this data to their advantage. If the research indicates more than 50 percent of

↑
Design for the small screen

Study online advertising to learn where the majority of ads are being placed—this should have a bearing on the composition of your images. Research shows that mobile devices are now where the majority of "browsing" is conducted. With such small screens, the images must be clean and simple, providing the graphic designer multiple opportunities to fill the screen with client messaging.

←

A blank canvas

This is a simple image portraying a celebration where the subject is in the centre of the frame. The white background allows the graphic designer to easily extend any of the four sides to fit any final layout desired, maximizing the image's sales potential.

↓

Banner ads

This is a beautifully composed example of an image suitable for a travel or tourism-related website banner. More than 50 percent of all advertising is now online. Photographers should supply content where the demand lies.

all advertising is in digital media, which is landscape format, then the odds of a sale should increase by shooting in this format. Make it easy for a designer to select your image, and not another.

The other important thing to be aware of when composing for digital media is to keep the design simple and void of clutter. The file size of a stock library image will most likely be around 50 megabytes; however, it's rare for an image to be larger than 5 megabytes when used online. Therefore, many of those nuances and subtleties seen in large images will be lost when viewed onscreen. Microstock is about simplicity, but that is a fluid statement: As technology advances, image quality will have to keep in step. ■

DEVELOPING STYLE

L et's get something straight right out of the gate: designers and other photo buyers that license visuals rarely, if ever, look at the name of the photographer. Consequently, if the photographer's name has no bearing on stock images sales, then image execution and impact are the only remaining deciding factors that may influence the ultimate licensing of the image. Therefore, it falls upon the photographer to develop a unique look and style to rise above the glut of material that currently exists.

How many different ways are there to photograph a doctor wearing a white lab coat standing against a white wall with crossed arms? Or, heaven forbid, the quintessential and ubiquitous sunset sky? Every agency has tens of thousands of these images, so how does the image buyer find yours?

In order for any image to rise above the crowd, a lot of work is involved. Typically this is non-paying work and all part of paying your dues. It requires discipline, passion, and dedication.

To develop a personal style, it is best to start with a self-assigned project that has an end objective. Make those first projects small with clearly defined outcomes. There should be a certain initial level of comfort with the content and the equipment should be rudimentary and basic—think of shooting in black-and-white and with one prime lens. These assignments are not about creating stock imagery, they are all about learning how to "see." Color can

Personal projects

A self-assignment could be as simple as photographing a solitary tree with a fixed-focal-length lens. Learning how a single piece of equipment sees a single subject allows the photographer to focus on developing a unique style and places the emphasis on their vision.

be a distraction. When the world is seen at a single focal length, the shapes and forms of elements within the frame are easier to "see," helping the photographer to position them better. Ultimately, as the body of work grows, themes and personal vision will start to emerge. This is the evolution of an individual *look*.

The assignments need not be difficult. The landscape photographer might want to consider making images of a single tree in the frame. It need not be the same tree, but it must be a single tree, forcing a particular sense of scale within the environment. The

street photographer might want to consider making images of hats in a crowd; only people wearing a hat can be the primary subject of interest. And for the doctor wearing the white lab coat? Perhaps the focus is only on the doctor's healing hands. Most importantly, it is critical that only one lens be used in these vision exercises.

As this is a personal project, the results must be showcased in a manner that appeals to you and forces introspection into your own personal style. You could have a blank wall in the office or studio and 10, 15, or 20 simple and reusable frames. As an acceptable image is made within the assignment theme, hang it on the wall so it can always be viewed and studied. As the frames get filled, you will start to recognize your vision, and as your style emerges and evolves, the images can be swapped for new and more pleasing ones. Throughout your career, the images on that wall should provide challenges to advance your technique and image designs, and by

default, continuously advance the promotion of a personal image style that will evolve into your signature.

As my mentor explained to me in the early 1980s, it is possible with time to teach ourselves how to truly see what we are looking at, and to look at what we are seeing. Only when that occurs will the photographer be able to move their image from the masses of competition and become the competition. That should be the objective in developing a personal style. ∎

↖

Rise above the rest

Photo buyers rarely, if ever, look at the name of the photographer. Consequently, the photographer must develop a unique style to stand out from the crowd. All photographers have a choice: Be with the competition, or be the competition.

↑

Embrace your individuality

Develop a personal style that makes your work unique.

COLOR WORKFLOW

n "The Digital Darkroom" section, a brief overview of a calibrated workflow was introduced. Obviously, if any one component of the workflow is not in simpatico with another, the final product is most likely not going to produce the intended result. Unfortunately, this occurs far more frequently than you would imagine, or is necessary.

As the photography and printing industries were migrating from analog to digital processes, there was serious disagreement and resistance among the user groups in developing a singular industry-wide standard. As a consequence, every commercial printer developed individual color profiles for their web and sheet-fed presses, and photographers were grappling to determine which was the best color profile. To suggest the relationship between the photographers, graphic designers, and printers was tenuous and strained would be somewhat of an understatement.

Fortunately, as the imaging industry evolved and matured, a mutual understanding was agreed upon: the stock photographer would accept Adobe (1998) RGB as the default working color space and designers would default to the printers' CMYK (cyan, magenta, yellow, black) color profile, depending upon whether the output was printed via a sheet-fed, web press, or digital printer. While the stock photographer's output will be in Adobe RGB (1998) format, it is essential to have a basic knowledge of CMYK color spaces.

With apologies in advance to any skilled photographers utilizing HDR technology,

overt, over-the-top use of HDR generates great examples of out-of-gamut images. By oversaturating the colors to mind-numbing neon renderings, many photographers bought into the trend for the HDR look. While the images had impact on screen, they simply couldn't print on paper. The primary reason is because the RGB model works by adding colors to arrive at a specific tone, whereas the CMYK model subtracts colors that would typically appear on a white paper background. Those high-contrast and oversaturated HDR images would turn "muddy" once converted to CMYK.

Graphic designers understand color theory better than most photographers and will usually avoid very color-intense images. They are aware of how unlikely it is to retain

↑

High-dynamic-range images

A heavily adjusted image using HDR techniques will garner attention due to the saturation of the colors. A designer might question whether the blue and magenta tones will reproduce accurately and this hesitation may be sufficient to encourage the designer continue searching for an image elsewhere.

the original RGB gamut once converted to CMYK; thus it is far easier to bypass the troublesome image and search for a similar one that will easily convert.

Fortunately for photographers, most image-editing software providers have made it quite easy to monitor post-production work to ensure the final result stays within the CMYK gamut. Without delving into a tome on color theory, Adobe Photoshop and Lightroom have made this process quite simple by pre-setting the parameters in the color setting dialog. If the photographer is following graphic designer or printer instructions, they will be given the press colour working space. The widely accepted standards in the imaging industry have been established over time, these are Adobe RGB

(1998) for images to be displayed onscreen, and CMYK for images to printed on sheet-fed or offset presses, with any gray and spot colors set to 20 percent dot gain. As a result, these standards should be accepted and established in the image software preferences.

An image with color impact is more likely to draw the attention of a photo buyer that is quickly scanning hundreds of images. If the use of color is over the top, it will just as easily be overlooked. You should always check the CMYK color gamut to ensure the image will print as intended. This should be one of the final functions in the workflow prior to saving the final as an RGB Adobe (1998) image. ∎

↖

The printing process

The skilled press operator can accurately reproduce RGB colors on either a web or sheet-fed press with CMYK inks, providing the RGB colors are within gamut. The photographer is just one element of the image reproduction process and should have a working knowledge of how images are printed.

↑

Color messaging

The photographer has done a good job of creating sufficient void space so that this image can be cropped vertically if necessary. The red and green complement each other, and the tones are pastel, in keeping with contemporary trends. If the red flowers were blue, the image would shout "RGB" and could be aimed at the digital design industry.

POST PRODUCTION

A s the capability of image-manipulating software advances, so too must the creativity of content providers to get the most from that technology. When Photoshop first entered the production studio in earnest during the mid-1990s, many studios recognized the pixel alchemist was going to be an integral component of image workflow. As a result, a new industry was born—that of the digital artist.

In the days of Ansel Adams and Yousuf Karsh, the astute photographer realized the skill set required to push images beyond the negative was best left to the trained darkroom artisan—those skilled in manipulating the latent negative. The better contemporary photographers also recognize that if they work in partnership with a digital artist the efficiencies in producing the final file are dramatically improved.

The next generation of photographers in the 2000s were more computer savvy and literate. In fact, many understand the nuances of image manipulation better than the technical aspects of lighting a subject. Regardless of what side of the equation we find ourselves, the microstock photographer of today most likely does not have the financial freedom to have an art department to complete the post production work. Consequently, the photographer must also have a very good working knowledge of Photoshop.

In essence, the success of the final output is directly proportionate to pre-planning. Thus,

post production begins with pre-production. In fact, if the photographer could eliminate the post production altogether, that would be the ideal situation, and, in fact, should be the ultimate goal. That, however, is unlikely to happen.

Much of the basic post work can be done in Adobe Lightroom, Corel's Paintshop Pro, or

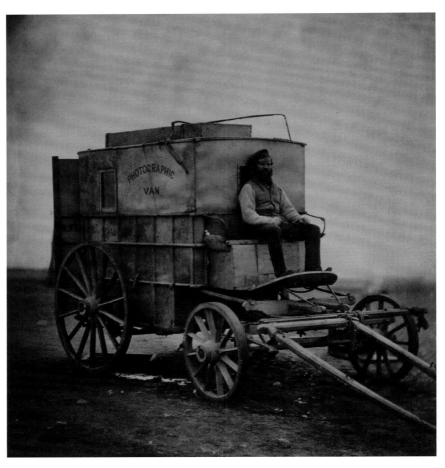

↑
Pioneering photography

Since the birth of photography, image creators have been manipulating their original images and making enhancements. Here, Marcus Sparling, Roger Fenton's associate, sits atop their photographic van in 1855. ©Everett Historical/Shutterstock

perhaps Apple Photos. Every camera sensor will have dust somewhere, and the only way to find it is to enlarge the image to at least 100 percent and go looking for it, and then ultimately utilize one or more of several techniques for its removal. Two methods for removing these dust spots are "cloning" and "patching," so it's vital these techniques are mastered. Without the correct edge sharpness on the brush, artifacts could be introduced as the algorithms attempt to manufacture pixels.

As a matter of course, it is good practice after each correction is made to quickly review that work in the red channel only. It is amazing how you can sometimes see poor corrections glaring through in the single-channel view. The errirs might not be seen in RGB mode, but if they can be seen in the red channel, it means they will more than likely appear as well coming off an offset press—not good.

In fact, after all post work is completed on an image, it is advisable to again review the image at 100 percent in each of the red, blue, and green channels. All too often an image will be over-processed in an attempt to "pop" the colors or create some effect through a third-party app, and this creates an ideal opportunity to introduce all manner of unwantables.

Always assume the end user, the graphic designer, or other creative professional understands these nuances of over-processing. If an image is being considered for a high-end campaign, there is no doubt it will be studied for deficiencies in each of the RGB channels.

Few things will lead to an image being rejected quicker than technical deficiencies. Study the image in Photoshop as a designer would, as they most certainly will—and by then it will be too late. ∎

↖

Stay abreast of new techniques

The challenges of post production that face contemporary photographers are little different to those addressed by Karsh and Fenton. The photographer must decide whether they are more skilled behind the camera or in using manipulation software; few excel at both. To stay current, annual refresher training is necessary to learn new techniques, and it should feature in budget considerations.

↑

Darkroom processing

The photographers of the 20th century were skilled in the darkroom or they employed technicians to get maximum detail from their negatives.

SHOOTING SCREEN

was fortunate to be in the right place at the right time. Throughout the 1990s and well into the mid-2000s, stock photographers could earn a lot of money while traveling the planet doing what we loved—making pictures. In doing so we developed large inventories of images, many of which stayed archived in some shoebox, never to see the light of day.

As the value of an image started to decrease below the cost of production, it became time to revisit the image cemetery. It simply was no longer possible to hire talent and support crew to produce a shoot in a distant location. But in that picture boneyard, many of us had beautiful landscapes. However, these were, quite frankly, a dime a dozen. How could they be used to create new, sellable stock images?

The answer lies in the screen. By using the images as backgrounds, a model that has been photographed in a studio on another day could be imported into the image in post production to give you a completely new scene.

Green screen or chroma key technology is not new. It has been around since the 1930s. It was only a matter of time before stills photographers embraced the technology. The photographer could resurrect those landscape treasures from years past, or go on location and shoot a scene as a background image for a specific project. However, and not surprisingly, it is not always as simple and easy as we would like.

There are few things that highlight a lack of skill more evidently than a poorly executed composite image. As obvious as it might

seem, there is only one sun; so regardless of how many layers are imported into the working image, they all must have the light originating from the same angle and with "believable" intensity. The same can be said with focal points. Again, a poor choice of images will scream "look how bad I am" should there be more than one point of focus in the image. As ridiculous as it may sound, it happens. Therefore, it is often best to select a background image that has a very obvious light source and focal point. These must complement the subject that will be imported. For example, if a fast-moving athlete is to be photographed in a studio for a composite, the best background might be one that is out of focus.

With the background selected, the next challenge is to photograph the model on a screen. This is typically green or blue, however some post-production artists prefer white or 18 percent gray. Regardless of the background color, it is critical to ensure the screen is evenly illuminated around the talent or subject in order for the extraction software to work well.

If you don't have a solid grasp of studio lighting techniques or of layer masking in post production, it might be best to learn the procedure before diving in with vigor. Alternatively, it could also be more cost effective to contract post-production work to a digital artist to learn how critically important each component is.

As stock photographers, the bottom line is the bottom line. Shooting screen allows you to develop concepts at lower costs by using existing background images.

↑

A super efficient method

Shooting chroma key, or green screen, opens up a whole new world of opportunities, allowing you to work smarter, not harder. Photographers can shoot backgrounds designed to be used in post production, or they can capture super heroes for clients to drop into their own backgrounds.

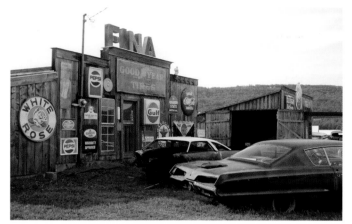

It all starts with a background and an idea . . .

A sky from the archives to fill in the woeful greys...

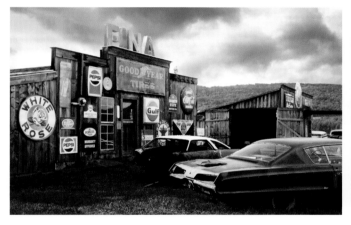

A little post production to create the grunge look that
is no longer popular . . .

A friend willing to go under the lights and sign a
model release for pizza . . .

Then pull Chris (not his real name) from the green using
specific software, and . . .

Voila—the final photo. This image was never made available for licensing
due to all the advertising signs which would restrict it to editorial use only
and even then with only very limited market potential. As photographers
we must keep exploring opportunities and ideas to simply push our own
boundaries. Creativity is restricted only by imagination.

THE SEARCH ENGINES

METADATA

magine being at the cusp of an evolutionary change in your industry. The technology is advancing faster than it is possible to keep pace. And when some of that new technology concerns a topic that is not particularly interesting to you, it's easy to delegate the new tasks to someone else.

Such was the case for photographers working directly under exclusive contracts with small roster agencies (by today's standards) with theme-centric collections. The collections were very tightly edited and it was not uncommon for agency staff to outnumber the photographers. Staff would do the editing, data entry, and attend to the barrage of other administrative jobs necessary to ensure a well-oiled machine was selling the pictures. And sell pictures they did, freeing the photographer to do what they wanted to do—make the pictures.

One of those administrative tasks became the input of metadata—words or phrases that described an image, allowing them to be searched for on digital databases.

Unfortunately, in some ways, the evolution continued to grow faster than anyone could keep pace. Eventually, the responsibility for inputting all metadata fell upon the photographer, and that raised a big concern: Most photographers didn't appreciate how finicky the task of accurate metadata implementation actually was, and the precision it required. Even worse, when the exclusive relationship between the photographer and the agency might be severed many years later, the metadata was often stripped because it was considered

proprietary by the agency that had compiled it using their own confidential protocols and processes. The photographer was now left staring at many external hard drives of images that had very little value due to a lack of metadata.

For photographers working today, it is vital to understand how to correctly input the relevant metadata for their images. As important as it is to learn the business of stock photography, it could be argued that managing the image files is even more important. Fortunately, many books have been written on Digital Asset Management (DAM), and it is strongly advised you study these to learn how the back end of file management is structured and how it works. Also, fortunately, editing software has made the process of data input much more streamlined and efficient.

↑
Traveling solo

This and the image opposite are two images along the theme of travel with similar metadata. The caption title for this image reads: Young Asian traveling backpacker in Khaosan Road outdoor market in Bangkok, Thailand.

Keywords: *travel, backpack, thailand, people, city, asia, asian, tourist, young, tourism, trip, bangkok, adventure, walk, market, vacation, street, journey, male, southeast, chinese, holiday, guy, nature, urban, hat, backpack, sun, bag, road, outdoor, day, concept, thai, freedom, alone, korean, khaosan, japanese, looking, adult, backpacker, copy space, daylight, exploring, man, person, rear, sunny, traveler*

The first thing to know is that metadata that is tagged to an image is done in one of two ways and can briefly be described as internal or external. The internal data is embedded at the time of capture and is an automated function, fixing the data within the image throughout the life of the file unless it is purposefully stripped out. This data will typically be the date, time, and creator. Internal data is established within the camera, and must be amended through the camera menus. External data is information that is input as a component of the post-processing workflow. This data is also resident outside of the image file and is usually attached to the image file in the form of an XMP sidecar.

Once the image is downloaded to the editing and post-production suite, you will need to decide what metadata to input. It is critical this data subscribes to an established set of protocols and controlled vocabulary for consistency. Fortunately, much of the legwork has been done by a consortium of news media agencies collectively known as IPTC. Yes, this is the same IPTC that is found in the File Info fields within Photoshop and Lightroom. IPTC has established industry standards through their work since 1965, and provides the taxonomy of each field.

Agencies will often require metadata to be input following their published schema, and obviously this should be adhered to. However, based on the photographer predicament as outlined above it would be prudent to have the photographer's master file populated utilizing IPTC standards, and archived for future considerations. ∎

↑
Happy travels

The caption title for this image reads: Happy smiling woman looks out from window traveling by train on most picturesque train road in Sri Lanka.

Keywords: *travel, sri lanka, train, trip, happy, window, railway, asia, tea, tourism, ella, blue, landscape, holiday, woman, adult, asian, beautiful, ceylon, cheerful, cute, eliya, female, fun, green, happiness, island, lifestyle, mountain, nature, nuwara, old, outdoor, people, railroad, smiling woman, sport, summer, tea plant, tea plantation, tourist, transport, travelling, view, vintage, wine, young*

CAPTIONS

f a picture is worth a thousand words, why do we need to write captions?

This is an interesting philosophical question that is only made more difficult due to agencies not being completely forthright with how their respective search engines operate. To be completely fair, agencies expend massive resources on back-end management and they rightfully are hesitant to openly share this proprietary information.

By the same token, more and more image searches are being done through online service providers, such as Firefox and Google. As a consequence, agencies also have to be finely tuned into the search engine optimization (SEO) methodologies of external search engines.

As with many other functions within the agency/photographer relationship, more onus is being placed on the photographer to fulfill what was at one time the responsibility of agency staff. Regardless of whether the intention is to market the work through an agency or independently, the photographer will need to complete the metadata using current best practises. Therefore, complete the metadata as if the work is to be marketed independently, and archive these files per internally established protocols. Should an agency be representing the work, make copies of the archive files and adjust the metadata to accommodate respective submission requirements. With this approach, the photographer always has archived Raw photos in their master file with complete metadata attached.

Redundant? Yes.

Necessary? Yes. There exists a real possibility that a collection might not be returned in a neat and complete package should a relationship with an agency be severed.

While always subject to change, it is best to think of agency search engines as crawling the many millions of images held in their collection by looking for individual keywords. By comparison, external image searches using Google, as an example, will place a higher priority on caption data tagged within the image. Thankfully, Google has gone to great lengths to make SEO relatively easy to understand. These tutorials can be found by searching for their SEO Starter Guide.

When writing captions, photographers should aim to "paint the picture" very methodically with descriptive words. The Description field in Photoshop (Caption in Lightroom) should answer the who, what, when, where and why that is visually profiled in the picture. Conversations with several IT folks that specialize in SEO have suggested a 50-word description will yield up to a 20 percent increase in search engine traffic than descriptions with more or fewer words. In Google language, the description field is identified as the "alt" attribute, and it's recommended you add a caption within the alt field in addition to the caption embedded in post production.

Just as key as the Description field, the title of the file is critical when completing the metadata due to being heavily weighted

→
The five Ws

Here is a simple method for identifying the information you should include in your captions. Pick out significant details in the image and then ensure you cover the who, what, where, when, and why. Most editing software provides for the easy inputting of the five Ws. Should there be a series of nearly similar images, the inputting of data is made easy by way of a software synchronization function.

WRITING CAPTIONS

Sunset Two senior men

Frozen lake Winter Ice fishing tent

TITLE:
Two senior men winter ice fishing at sunset
(46 characters)

CAPTION:

Who: Two retired senior men with beards
What: Ice fishing for trout in shelter of winter tent
Where: Frozen Penhorn Lake, Nova Scotia, Canada
When: January with light snow falling
Why: Relaxing and having fun in retirement golden years

Two retired senior men with beards enjoy the success of their golden years of retirement by relaxing and having fun while winter ice fishing for trout on the frozen Penhorn Lake, Nova Scotia, Canada. A light-falling snow at dusk completes this favorite winter pastime and hobby.
(48 words)

in importance by most search engines. This is the place to be brief and concise, and include the main focus of the image. Again, deferring to the IT folks, it is suggested titles are optimized at 50 characters. Once the title extends beyond 55 characters most search engines will truncate the titles, potentially causing the image to slip down in search rankings.

Search engine optimization can be complicated, or it can be made user-friendly. It really becomes a matter of how thorough you wish to be in learning the nuances.

Stock photography is a business and getting the images seen is paramount to it operating successfully. Developing a solid SEO policy could be enhanced by hiring expertise for a day of in-house training.

As important as the title and descriptive caption are, precise keywords remain the single most important component, as we will see overleaf. ■

KEYWORDS

I f the caption and title are the prince and princess of metadata, then the keyword is king. When thinking of what keywords to tag to an image, it is critical to remember that not all potential clients will search for the exact phrasing embedded in the caption and title fields. Therefore, think of the keyword as an expressive means to help you further paint your picture with more words—relevant words.

Trying to learn how each stock agency scans its database searching for images with proprietary search engine algorithms is a tenuous exercise. However, it is becoming more common for potential clients to start their searches through a public search engine such as Google. Consequently, the efficient photographer should apply keywords that subscribe to external SEO protocols to maximize exposure and potential sales. For comparison, one major agency, until just recently, only wanted conceptual keywords applied in the keyword field. By all accounts, it now appears most major agencies also accept keywords from a non-proprietary thesaurus to maximize the external searchability of an image.

How one approaches keywords will most likely depend on whether the work is going to be represented by an agency or through the photographer's own portal. Agencies have their own established protocols and these have to be adhered to, however, it is wise to also include keywords during post production as there is a very good chance the image will not reside with just one agency during its lifetime, and these keywords, as well as other metadata,

can be held with the archived collection in perpetuity.

This is the time to expand on the who, what, when, where, and whys identified in the Description field. This is also the place to input those critical keywords, buzzwords, and conceptual taglines that have been ever expanding over time. For example, "tip of the iceberg" is a common conceptual tagline that has been used over many years by advertisers; consequently, this tagline input as a keyword phrase will potentially open up your image to more buyers than the solitary keyword "iceberg."

The iceberg example also raises another issue: spelling and language. Should that be iceberg or iceburg, and what color or colour is it—blue, bleu, or azul? Whereas the correct

↑
Tip of the iceberg
The primary calving ground in the northern hemisphere is along the west coast of Greenland. Most photographers know this. What many don't realize though is that should they simply insert "tip of the iceberg" into the keywords or caption data they will rise to the top of image searches. Rise above the waterline; don't flounder in the depths with poorly tagged images.

Keywords: *iceberg, arctic, calm, cold, climate, cruise, extreme, floating, frost, frozen, glacier, global, greenland, ice, iceland, jokulsarlon, lagoon, lake, landscape, melting, mountain, nature, north, polar, sea, snow, travel, warming, water, white, winter*

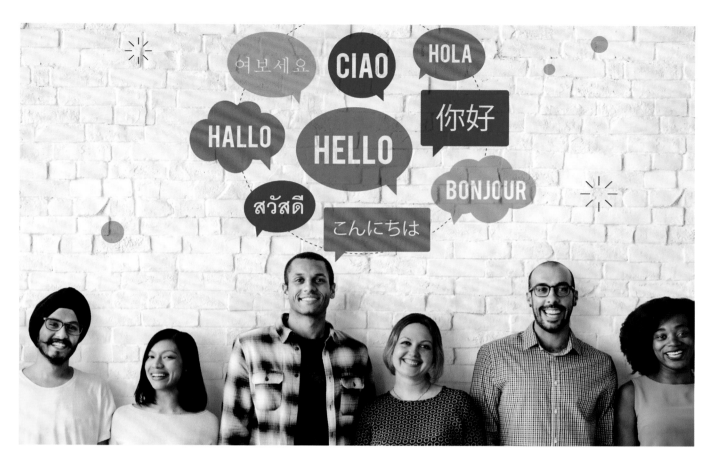

spelling is iceberg, it is quite astounding
how many times searches have come in
using iceburg. This creates a dilemma—
should you include incorrectly spelled
words in the keyword set knowing it could
very well be a potential search word? It is
recommended only correct spellings be
employed by default for a whole variety
of reasons. In the case of American versus
British spelling, it is generally quite
acceptable to input both. Language choice
creates much debate and again will be
determined by whether the photographer
will be going indie or seeking representation.

English is often thought to be the most
spoken language in the world, and as such
all metadata should be in the English
language. However, it's actually incorrect—
Mandarin tops the list, followed by Spanish,

and then followed by English. What might
be more accurate is that the majority of
photo buyers speak the English language,
and as such metadata should be input in
English. Should English not be your first
language, then opt for what is and allow the
agency representing the work to translate
as necessary. Should the work be presented
independently, then translation services will
have to be considered.

Once again, many books have been written
on SEO and keywords, and they should be
consulted due to continual updates in
procedures. It is not necessary to become
an expert, but a solid working knowledge
is required to maximize the sales potential
of your images. ∎

↑
Translating keywords

Thankfully, if you are contributing
your images to an agency, no foreign
language dictionary is necessary; the
agency will translate the metadata
for you. Should you be marketing
the image yourself, you will have
to decide whether the translation
cost is worth the potential return
(probably not).

Keywords: language, *different,
foreign, hello, people, culture, group,
asian, english, thai, worldwide, friends,
diverse, international, isolated,
communication, bonjour, smiling,
speech, team, bubble, various,
colleagues, adult, african, casual,
chinese, ciao, connection, descent,
diversity, ethnicity, friendship, fun,
graphics, greet, hallo, happiness, hola,
japanese, meet, men, multi,
multiethnic, of, on, talking, together,
togetherness, unity, white, women,
word, young, youth*

RECURRING PRIMARY KEYWORDS FOUND IN ACTUAL ADVERTISING COPY FROM A VARIETY OF MAGAZINE AND NEWSPAPER SOURCES

A	Abundance, Accuracy, Adventure, Achievement
B	Beginnings, Balance, Beauty, Bright, Birth
C	Celebration, Competition, Confidence, Creativity, Cooperation
D	Determination, Discovery, Dependable, Dawn, Dreams
E	Elegance, Energy, Excitement, Everlasting, Excellence
F	Freshness, Friendship, Freedom, Faith, Financial
G	Growth, Guidance, Glamour, Global, Golden
H	Hope, Health, Happy, Harmony, Hot
I	Individual, Inspire, Idyllic, Intelligence
J	Joy, Journey, Justice
K	Kindness, Knowledge, Keep, Key
L	Love, Luxury, Leader, Leadership
M	Majestic, Motivation, Motion, Momentum
N	Nurture, Nature, Nice, New
O	Outcome, Order, Opportunity, Organization,
P	Positive, Power, Performance, Pacesetter, Partnership, Profit
Q	Quality, Quick, Queer
R	Relaxation, Romance, Respect, Reward, Risk
S	Solitude, Skill, Strength, Speed, Strategy, Success
T	Time, Together, Teach, Teamwork, Technology, Travel
U	Uniform, Unique, Unity
V	Vision, Victory, Value
W	Winner, Wealth, Warmth, Wisdom
X	X-Ray
Y	Youth
Z	Zest, Zen-like

ACTUAL COPY AS APPEARED IN MAGAZINE ADVERTISING

Top performance

Staying ahead of the competition

Dawning of a new day

Long range view

Partnerships in business

Aiming high

Tip of the iceberg

Every minute counts

Global communications

Precious moments

Number one

New Age

We work for you

Mixed signals

Nothing ventured, nothing gained

Efficiency and productivity

Safety in numbers

Brilliant ides

Making dreams come true

Stay focused

Ahead of the pack

A winning strategy

Teamwork to success

Nothing stands in our way

A winning team

Lines of communications

Painting yourself into a corner

Closing the deal

The missing piece to the puzzle

Perfect pitch

Symbol of trust

Reach for the stars

Top of the heap

↑ ↓ ↘

Dawning of a new day

Sunrise and sunset pictures are . . . well, a dime a dozen. It is how the photographer interprets and represents sunrise as more than just a pretty picture that is critically important. These three images all show different takes on the theme. The sun rising over a cityscape has different connotations to the landscape image.

THE PICTURES

INTRODUCTION

As you delve into the nuts-and-bolts of stock photography, it becomes quickly apparent it is a world of clichés and metaphors. What might be surprising to many is that it is not the photographer that conjures these catchy phrases, that is left to the copywriter at the firm that has licensed the image to visually message a tagline.

Most likely the copy has already been written and approved, and the creative director has already sketched some conceptual drawing. The photo researcher is now looking for that perfect image that best supports the tagline and meets the creative team's concept.

Photographers may not be the sharpest knives in the drawer, but those of us who were shooting stock prior to the days of the internet—hard to imagine as that may be—were students of the business. Our very existence depended upon each individual photographer deciding what to shoot, how, when, and why. We came up with clever ways of tracking what images had been licensed in the past, and why. More importantly, we tried to discover why certain images weren't moving, and why.

There was no internet so more than 95 percent of all licenses would be printed on paper-based media. We would subscribe to 20, 30, or even 40 magazines and leaf through those every month. The vast majority had no interest as reading material;

we were only interested in seeing those half-page or larger advertisements. These big pages of advertising translated into dollar signs—the bigger the page, the bigger the dollar sign. From these pages each tagline would be read, and the keyword or buzzword would be highlighted in yellow. The page would be torn out of the magazine and the tear sheet would be stored in a three-ring binder.

The exercise paid dividends and it wasn't long before trends started to emerge. The

↑

Conveying a message

What makes a "working photo" is difficult to explain with precision. It need not be a literal interpretation of work, although it can be. It must be an image that visually conveys the message the creative team is dispensing. Understanding how art directors and copywriters use words to emphasize their message can enhance the marketability of your images.

→

Visual metaphors

Creative writers often use metaphors and a play on words when selling a product or service for their client. Therefore, let's *roll up our shirt sleeves, put on our work boots, get our hands dirty,* and learn what makes a working image.

same buzzwords kept appearing, and all copywriters were promising readers they could stay ahead of the competition by letting nothing stand in the way. With binders full of tear sheets and notes scribbled in the margins, the photographer was able to target their shoots toward the same words the copywriters kept using.

So was born a "working" picture. Pretty pictures are just that—pretty. One sells, the other doesn't.

The buzzwords and taglines being used today are essentially the same as the ones being used in the 1980s, and earlier. What has changed is the way they are used. The stock photographer today must continue to be a student of the business, not so much in recognizing the buzzwords and taglines, but in how to visually reinvent these clichés. This is no small order.

Many of the images included in this section are stereotypical, and to some degree that is by design. The point being, the material that is being used as a successful stock photograph today will no longer be in vogue

by the time this page is read. The stock industry is evolving that rapidly—a stellar image now has a much shortened shelf life than it would in 1985. By necessity, the successful stock photographer of tomorrow will already be thinking toward shoots in 12 and 18 months from now.

Take these image categories, develop some sketches using the taglines and buzzwords, and try to envision what will be in demand 18 months from now. The words won't change, but how you interpret and bring new life to those words had better if you wish to succeed.

Teach yourself how to make a working picture to rise above the crowd, raise your level of productivity, and be the competition. ■

AGRICULTURE

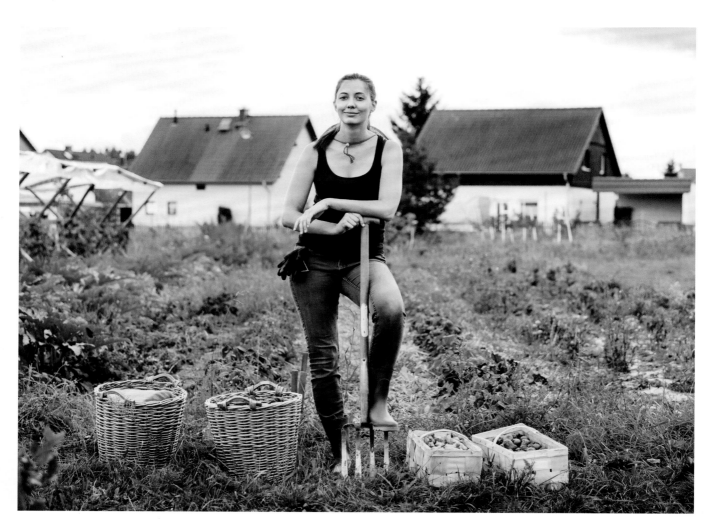

↑

Farming trends

When we think of agriculture, the first thought is of
large commercial farmers. There is a growing trend for
homegrown and organic produce, resulting in a very
niche market for images profiling the urban farmer. The
market may be small but should not be dismissed. Expect
growth, particularly in the editorial markets.

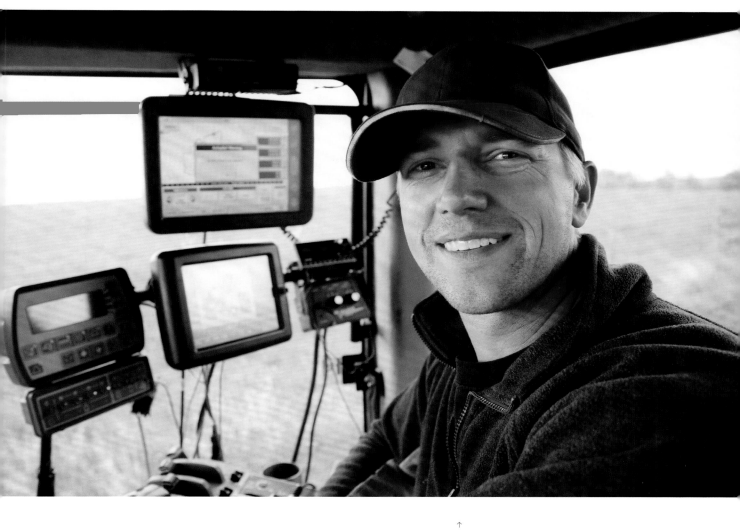

↑

Modern farming

Today's farmer is no longer the straw hat man leaning on a hoe. The tractors and harvesters are filled with computer and telemetry equipment that require a whole new skill set for many farmers. This technology has resulted in opening new fields for computer and software manufacturers as well as training facilitators. The astute photographer will grasp the opportunity to capture the new age of agriculture.

↓

Niche but necessary

Happy pictures sell, and one would be challenged to call
this a happy picture. It is reality—the image shows a
farmer spraying an unknown chemical on new growth
corn. These types of images are needed, but expect sales
to be limited to small-volume editorial use.

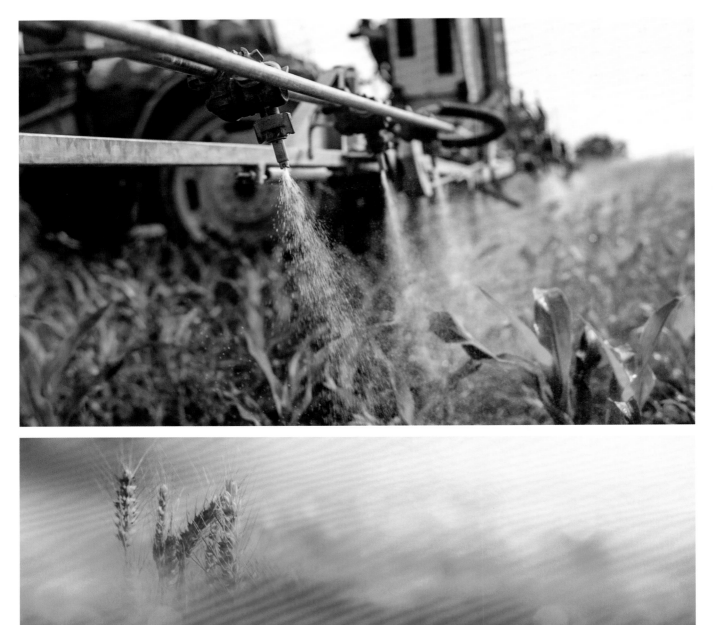

←

Reaping annual rewards

A classic view of kernels of wheat cropped for a web page banner. The void high-key space on the right side is perfectly out of focus, allowing the graphic designer to drop logos or text onto the image. This type of image will find sales year after year. Just as the wheat will be grown year after year, the smart photographer will create good, clean images every year to ensure they always have material at the top of the search engine results pages.

↑

Be generic

Science will always play a large part in the agricultural field as growers try to stay one step ahead. Well-executed still-life images will always be in demand, but care must be taken to remain generic. Does this image showcase GMO research or traditional hybrid development of new plants? The photographer should allow the copywriter to make that decision.

BACKGROUNDS

↓

Consider your focus point

At first glance this appears to be a great background image for either dropping in a second image or simply adding text in the left-hand void area. However, look closely where the focus point lies—one third of the way into the frame. This means any image or text that might be added will also have to be out of focus in the foreground. Care must be exercised when shooting backgrounds with particular attention to focus points.

↓ ↙

When in doubt, throw it out . . . of focus

Out-of-focus images such as these "hospital backgrounds" provide a plethora of opportunities. Models can be shot against a white screen in the studio in the course of a single day, and then transported into backgrounds during the remainder of the work week. By shooting out of focus, the location becomes unidentifiable and negates the need for a property release.

↑

Dramatic backgrounds

This is a great example of a really simple backdrop that has the potential to add drama to any supporting image to be shot on screen. Locate a vacant car park and get permission to shoot. Source a local music store that caters to nightclub bands; they typically rent out smoke machines for a very low cost. A small background light positioned behind the smoke establishes the drama and generates a high-impact image with unlimited potential. Too easy—just let your imagination soar.

←

Creative opportunities

This image has a similar setup to the blurred backgrounds. A business person could be placed on the left side to cover the in-focus component, or, alternatively, you could place a person walking into, or even out of, the foreground. By thinking creatively when shooting backdrops, not only can the image be used as a stand-alone stock image, it can also be used to supplement your own creations.

↙

Room for interpretation

Who doesn't love a tropical holiday? Leaning palm trees are a classic motif, and by using the right camera height and leaving sufficient empty space it is possible to keep on producing beach scene images back in the studio when the snow is flying outside. A whole variety of family-type vacation portraits can be dropped in a background as cleverly composed as this.

→

Textured backdrops

Many think of background elements as flat, one dimensional surfaces. This could be the case, but interesting backgrounds should not be dismissed. Their use is limited but can potentially provide some small supplemental revenue.

BUSINESS

↓

Working together

Few images show the teamwork motif as well as rowing. The team must all be in unison and rowing with power in order to be successful. These are the same messages the business firm will be showcasing in their advertising spreads.

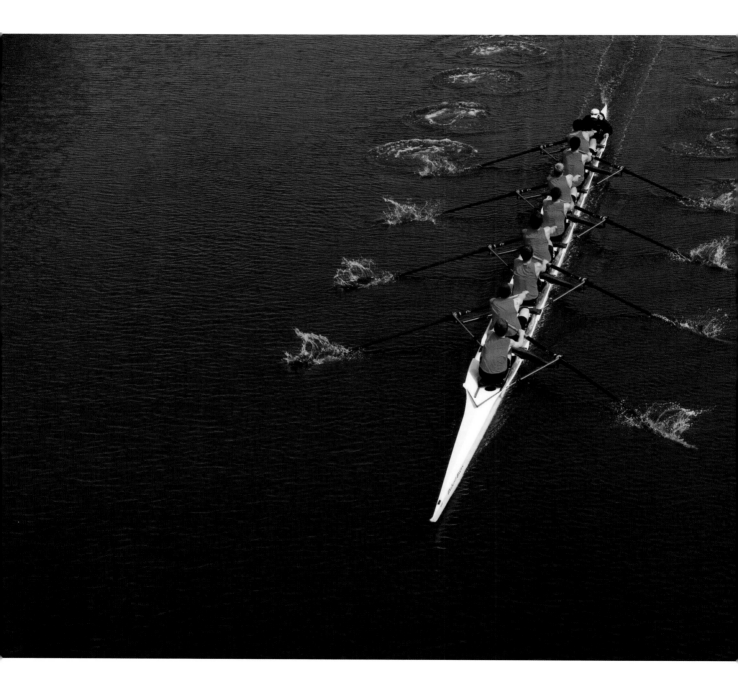

↓
Clever strategy

Well-manicured hands, bright and airy, and holding the white piece, as opposed to black, are all indicators this firm knows all the right moves.

↓↓
Conceptual solutions

There are many thousands of images of business people in boardrooms, often featuring gray-haired men sitting at boardroom tables and a scowling CEO who knows best. On the flip side of the coin, there are far fewer conceptual images that identify the pillars of business. All businesses want to suggest they have the missing piece to the puzzle, or the final piece of the puzzle. Think of relevant conceptual buzzwords and taglines, and visually portray those in a refreshing and contemporary way.

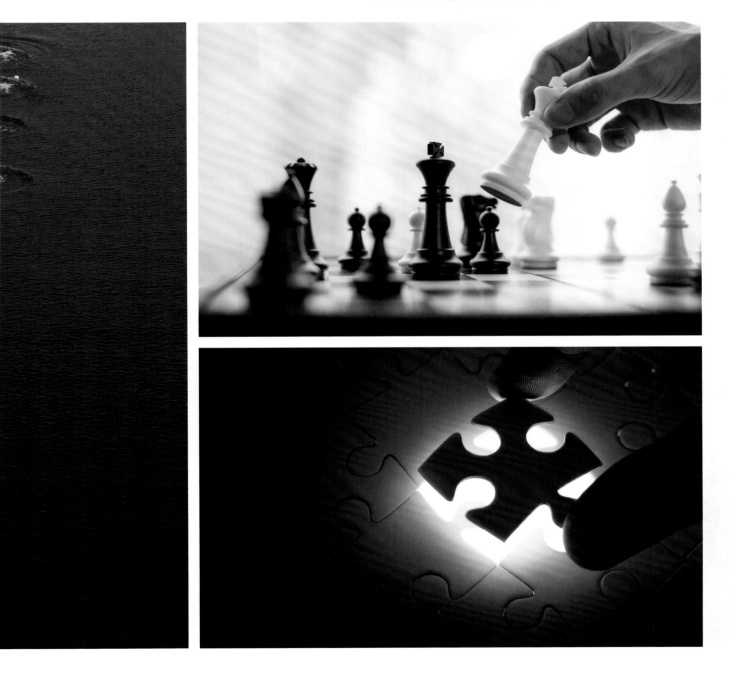

CONCEPTS

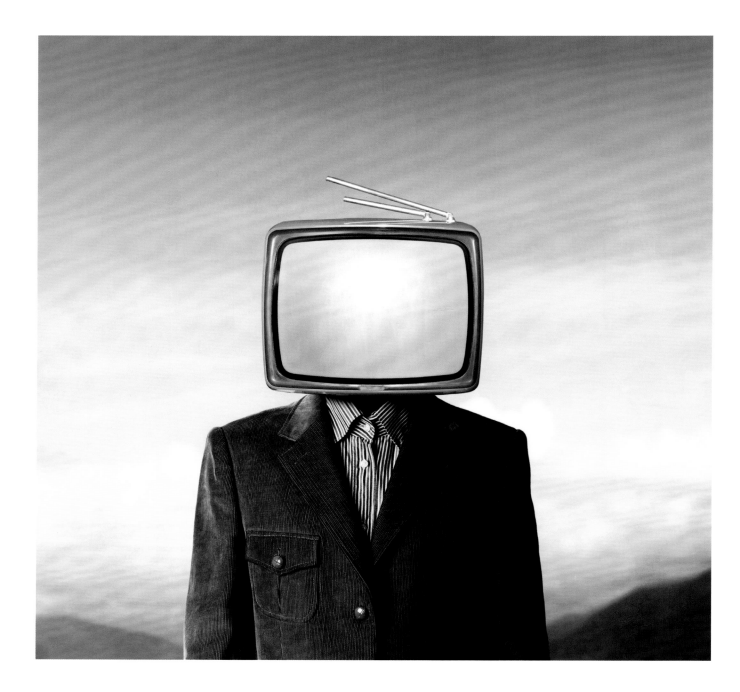

←

An abstract mood

At face value, conceptual imagery can be extremely difficult to execute. Interestingly the photographer opted to give this concept a retro feel and look, perhaps hoping to appeal to the sensibilities and nostalgia of the 1970s-born ad agency executive that approves the photography budget.

→

Bright spark

A bright idea is always a good idea—unless the prop is dated. Most countries have been transitioning from incandescent light bulbs in favor of energy-saving LED lights, for example. Will the traditional incandescent lights limit the market potential of this image? Potentially, yes.

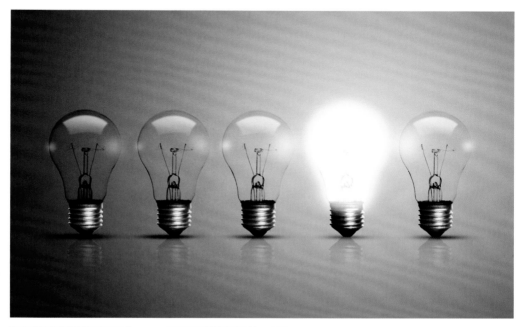

→

Step-by-step success

The concepts of the ladder to success and climb to the top are easily captured with this well-executed image. By identifying the tagline, developing the concept, and photographing the elements, the photographer is able to execute a marketable image with clear precision.

→ →

Conceptual range

The road to success, a bright spot at the end of the road, and the beginning of a new day are three taglines that immediately come forward from this one image. By extending the conceptual range of the image, the sales potential is increased proportionately.

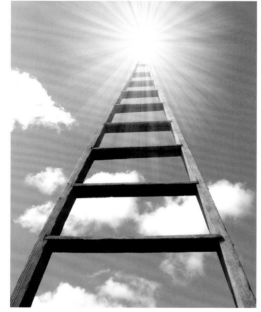

→

Stock heroes

Superheroes always appeal, and who can say no to the youthful exuberance of a child. By shooting from a low angle, the photographer has elevated the concepts of power, strength, and success.

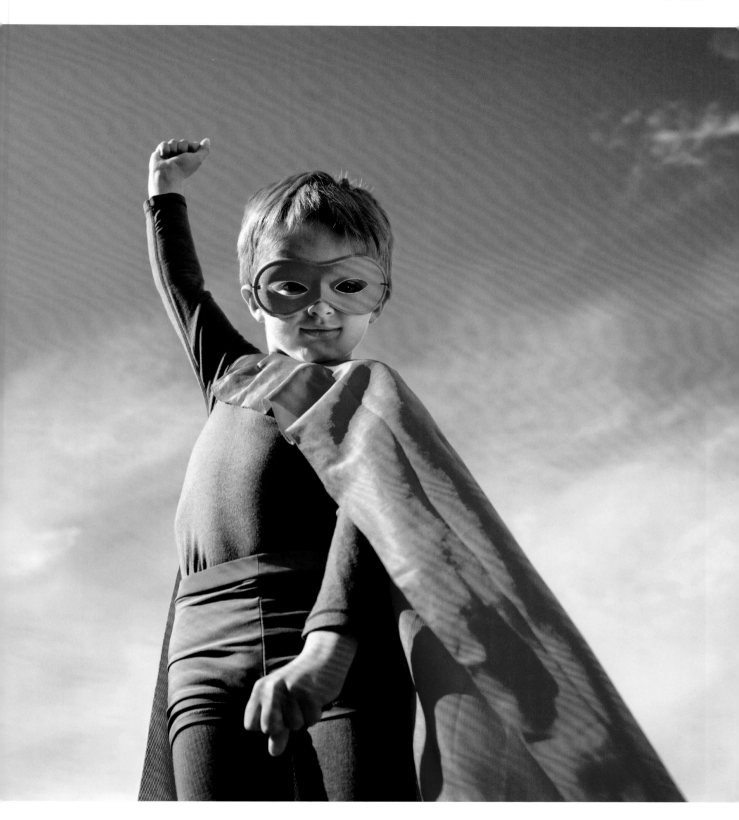

←

Investing in the future

Concepts work well in the education category. A financial or insurance institution would consider this image for promoting their service as well. The iconic piggy bank could signal saving for the future, or protecting your educational investment, until you notice the image is a poor composite. See how the the right-hand side of the table is not on the same focal plane as the book shelf? When compositing images, attention to these small details is critical.

←

A bright future

A very generic and bright image that is well composed and clear in its message. These graduates are going to be tomorrow's leaders. They will be bringing a brighter future, having shown academic excellence. When the stock photographer uses taglines to develop working pictures, as opposed to pretty pictures, the visual message becomes much clearer and as a result make the image much more marketable.

↓
Strong bonds

As important as generic is, so too is the requirement to be inclusive. This is a beautifully produced image with consideration given to cropping, supporting elements, and cultural diversity. Beyond that, these girls appear as if they truly are friends, and the school is where the future begins.

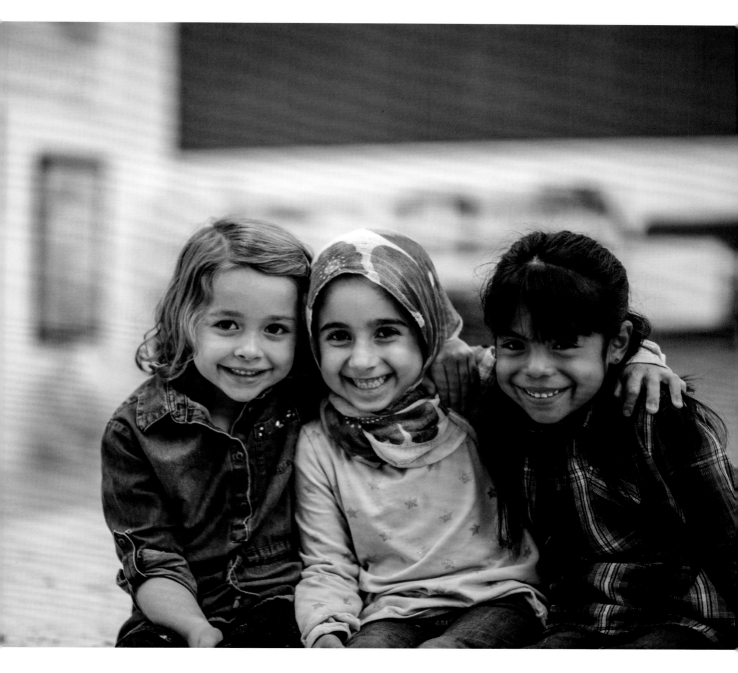

ENERGY

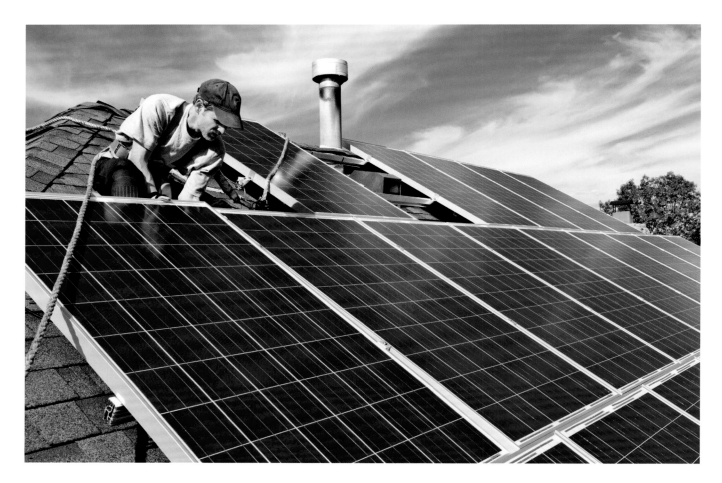

↑

Take the proper precautions

Are solar panels about to replace wind turbines as the poster child for renewable energy? Many of the images available are of large industrial solar energy farms. Solar panels are becoming more popular with residential homeowners, thus opening more marketing opportunities for the stock photographer. If taking an editorial approach, ensure any workers included in the picture are properly outfitted with Personal Protection Equipment (PPE); those lacking the proper safety gear will most likely seriously restrict the image's usage.

→

Details, details, details

At first glance, this is a nicely executed image. However the sun is behind the collector panel, thus not generating energy and possibly eliminating advertising sales potential, especially so when the observant photo buyer recognizes the sun and shadows are not in alignment.

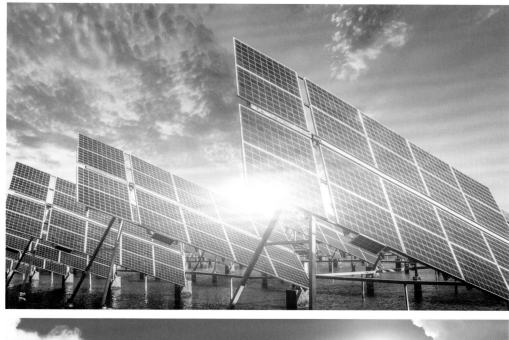

→

A bright future

This image may look too clean. However, it does have all the positive attributes a potential user might be looking for: clean sky, sun reflecting off the solar panel, residential application; all are components that should be included in your mental checklist when looking for locations to photograph in this growing market.

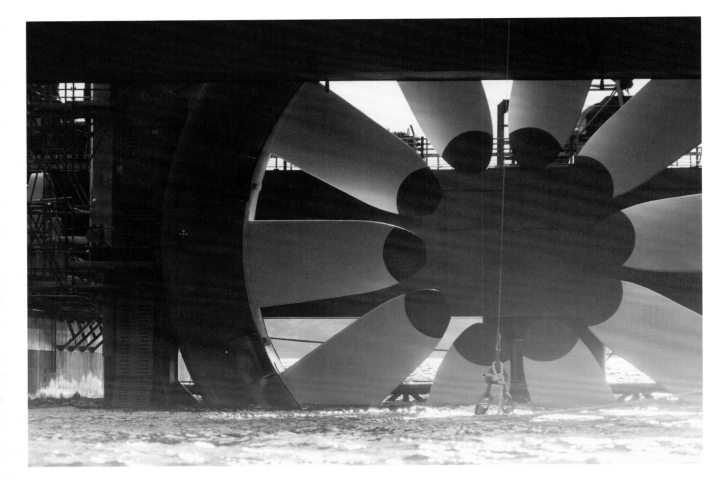

↑
Envisioning the future

Tidal power turbines are a
contemporary approach to
renewable energy. Considering there
are very few stock images available
covering this subject, a well-executed
collection could pay dividends when
the technology becomes mainstream.
Just as renewable energy concepts
require vision and good execution,
so too does stock photography.

→
Winds of change

A nice composition that will provide
ample flexibility for the designer.
Slowing down the shutter speed to
around 1/15th of a second captures
the movement of the blades
perfectly. The brown spots in the
grass could have been "colored"
green in post production. All in all,
this is a good image, conveying a
green energy concept.

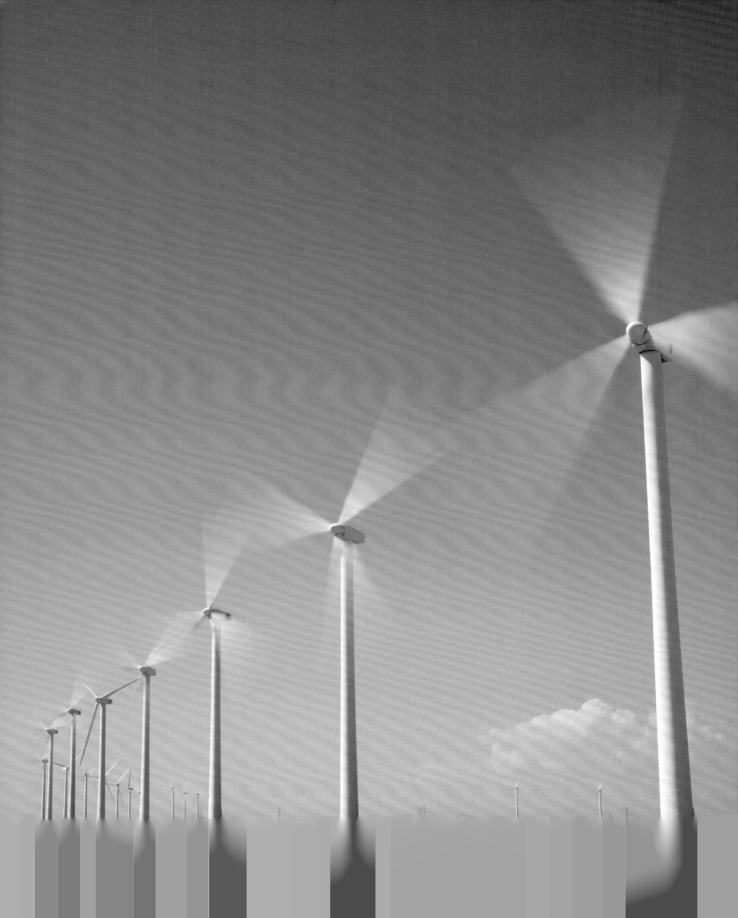

FAMILY & LIFESTYLE

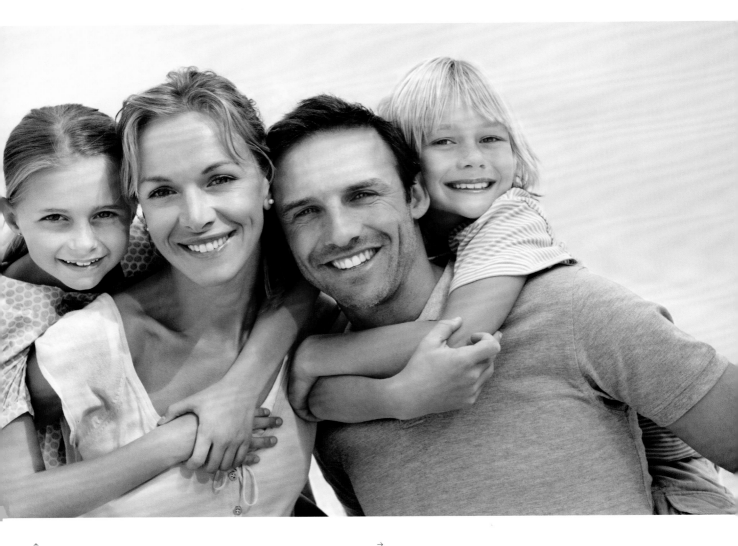

↑

Happy families

Much like the mother and daughter image opposite, this picture will find a broad range of uses; or will it? One of the many obstacles photographers have to overcome is young talent with fake smiles. For many generations, parents have been telling their children to smile for the camera. Unfortunately, a fake smile can be easily spotted and may be sufficient to limit potential sales. Every child responds differently to direction, but always bear in mind the smile starts with the eyes.

→

Quality lifestyle

This is an extremely well-styled shot and could be used in many different situations in many different countries. It is neutral in every respect, with even the script on the wall hanging being sufficiently out of focus or easily changed. This image conveys the idea of enjoying the simpler things in life and of having a good quality of life.

↓

Tender moments

Mother and daughter images such as this will often find a place in healthy lifestyle brochures and pamphlets that can be found in health centers and pharmacies. Keeping the image warm, high key, and carefree will allow those precious moments to translate into sales.

↓

Memories in the making

This is a very simple concept that once again capitalizes on significant moments in time. Most children have at one time or another made a tent in their home and pretended to have a camp out. As a result, such an image pulls at the heartstrings of even the most grizzled photo buyer, and they remember their experiences of makeshift tents, flashlights, and pillow fights.

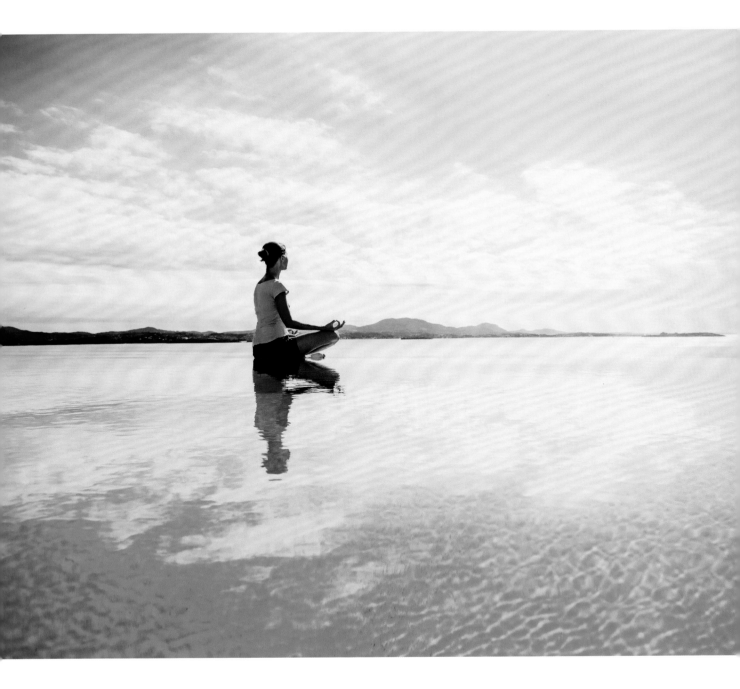

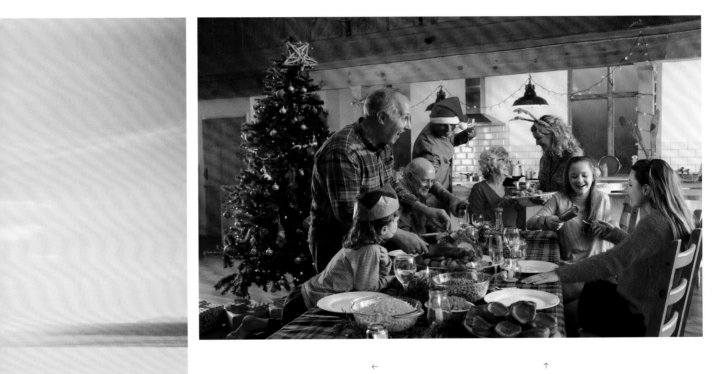

←

Channeling your talents

The lifestyle category includes a wide spectrum of potential image types. For photographers who prefer, or whose strength is, landscape, by simply adding a small person to a scene the image moves from being merely a location photo to a location and experience photo. This image conveys the enjoyment of place and solitude, and a zen-like experience.

↑

Universal themes

Festivals, events, and celebration are a time when family togetherness is at its best. Christianity is the largest religion in the world, but care must be taken when propping and styling a Christmas shoot as not all countries celebrate with Santa Claus or a tree. Regardless of the religious faith portrayed in a festive image, the common theme should be of family and togetherness.

FINANCE

The bitcoin bubble

Fad or serious contender? The bitcoin has become the talk of financial halls, and the stock photographer should not worry about the future of national economies and financial institutions. If the topic is hot, it means potential communicators will need images to support their message. Be creative and push the contemporary envelope—cater to the zeitgeist.

Create composites

A simple way to create a financial still life is to generate the image using elements that have been shot and saved with transparent backgrounds. Start stacking these elements as open layers in Photoshop and adjust to taste. Consider photographing the actual monitor screen and add that texture to the final image. Even a little controlled glare helps to add a taste of reality.

↓

Reflect real life

Who goes to the bank anymore? Forget about the hassles of photographing a bank teller and concentrate on the future—banking from the convenience of your home or a coffee shop. Care must be exercised to ensure the motif remains evident, otherwise the image loses its narrative.

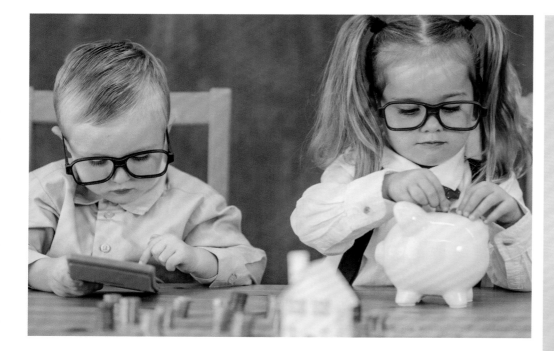

↑
Saving for the future

This is a fun picture that will lend itself to a whole variety of potential taglines. A financial institution could use this image for suggesting children should open a savings account with their bank. A more contemporary image might make use of Pantone's "Color of the Year" or the high-key style, which could give the image a higher level of marketability, but the concept is most certainly strong.

→
A smart investment

A nicely executed and composed image using an international icon of saving—the piggy bank. The clever use of little people chairs and the pile of books all suggest saving for future education. Complementary props and color all add up to make this an image with huge sales potential.

FOOD

←

On trend

As poor personal health continues to be a topic of concern, the promotion of healthy eating is rising. These are relatively easy concepts to interpret visually, but care must be taken when styling the model. Wristwatches are generally perceived to visually dissect the arm and are best avoided. They could also date the photo as more people rely on their mobile device to tell the time. The model's shirt has a stitched pleat which will also date the image. Be particularly careful to remain as "date neutral" as possible.

→

Beautiful produce displays

Imagery of grocery shopping has long been in demand. Just as wardrobe and hairstyles change, so too do stores in how they present produce. When a really attractive market display is located, the astute photographer will also shoot the background elements—without the model—for future compositing.

→

Professional food styling

Nice, clean shots of the food groups will always be in demand. Styling and lighting are critical, and far more difficult to successfully achieve than one might first think. Many food photographers will hire a food stylist, it is these professionals who are experts at making the food look, well . . . yummy.

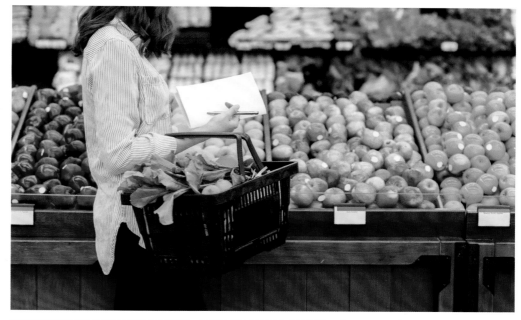

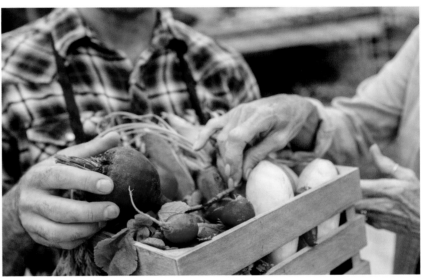

←
Capture appetizing colors

A nice simple shot of a chef working in a bistro or lunch bar setting. Contemporary food photography tends to be high key, so care must be taken when lighting the scene. The green colors of some produce and herbs do not photograph well or easily. Leaf lettuce, for example, will often be substituted by another green leaf to avoid the non-appetizing browns that inevitably appear if it's even the slightest bit underexposed. This, again, is where the experience of a good food stylist can be a big help to the photographer.

↑
Cater to trends

"Buy local" is becoming the mantra in North America as many urban centers establish farmers' markets that encourage the local farmer to sell direct to the customer. Be aware of your "farmer's" hands and ensure they look like a farmer's hands—not overly manicured. When designing this type of shoot, think "organically grown" produce and show this in the image; it will broaden the market potential.

HEALTH & WELLNESS

↑

Clever composition

As the predominant use of images transitions from print to web-based presentation, the photographer must also adapt how the image is framed in order to achieve maximum sales potential. By positioning the model in this location, the image can be cropped to accommodate numerous formats with ample void space to allow for text.

→

A powerful image

This image of a high-performance athlete is beautifully executed to show explosive strength, power, determination, and speed. It was most likely made with editorial use in mind, but can also easily crossover into advertising use.

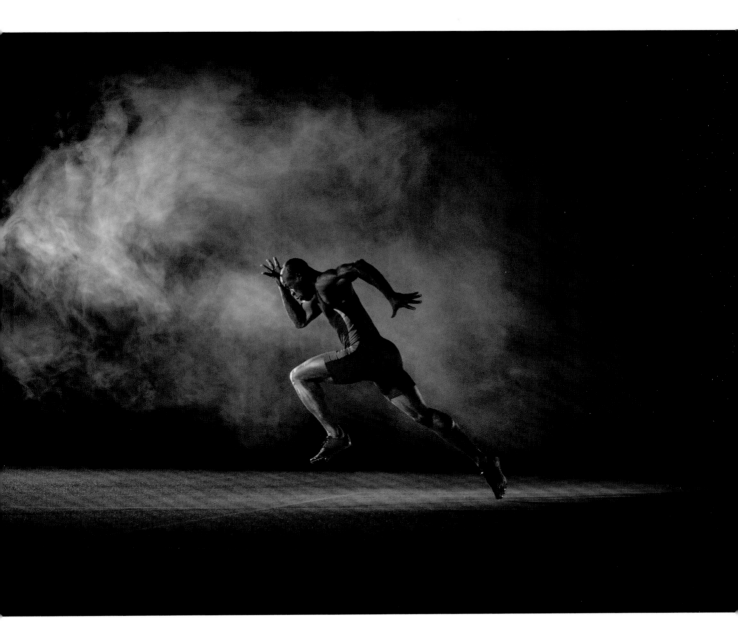

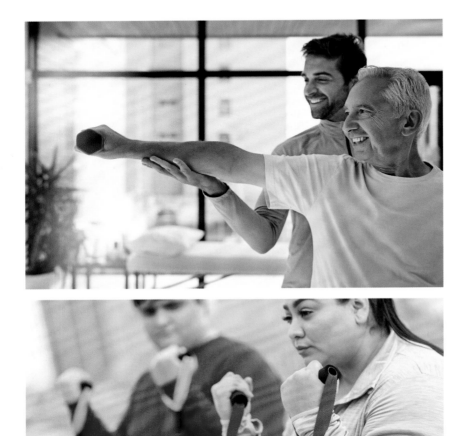

←

Fitness for all ages

Light, airy, and happy images will usually win clients at the end of the day. A large industry caters to the health and wellness of seniors. This category can pay well and deserves more than a passing interest.

↙

Fitness for all figures

Not all models have a muscle-chiseled physique. This is an image that shows a plus-size model; just the type of person one might see standing alongside the majority of people who are in exercise classes. This is an image that could be used in a wide array of health and fitness brochures.

→

Perfecting positions

Yoga is a globally practised form of exercise for both body and mind. This is an example of good framing that permits the mind to explore, yet it has restricted cropping options and thus limited sales potential. A looser composition would provide more options without changing the nice placement of the model. If possible, it is also best to remove jewelry—don't provide the end user the opportunity to see distractions.

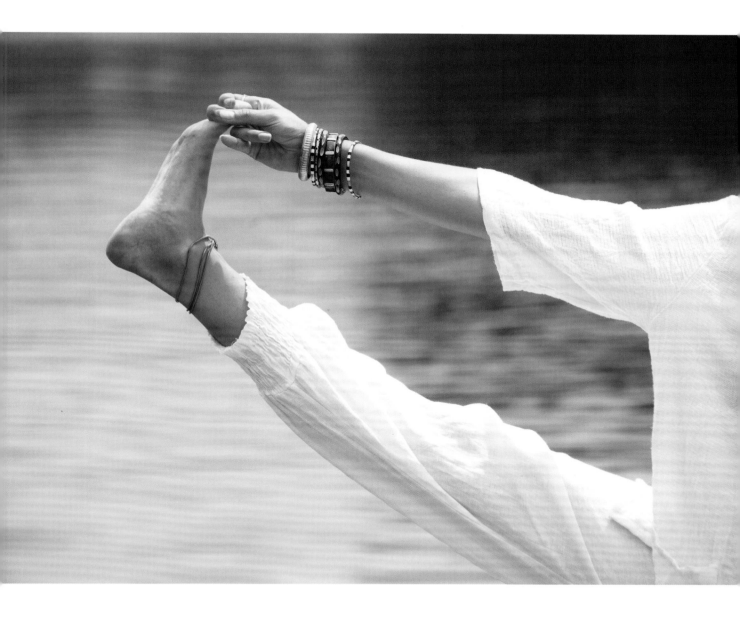

INDUSTRIAL

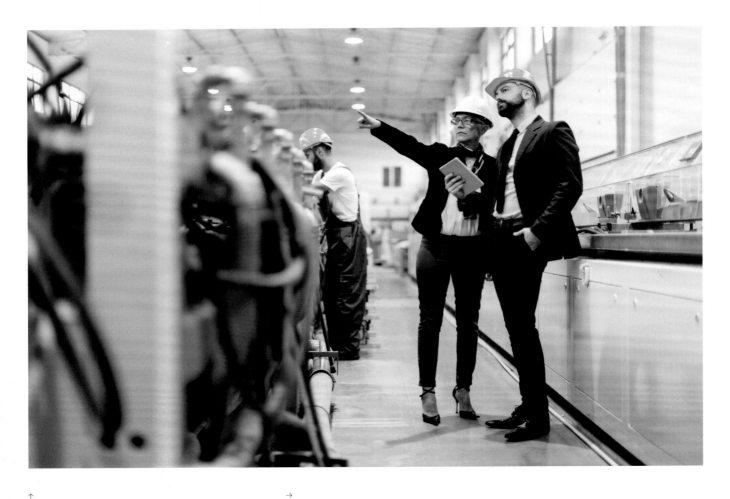

↑

Small gestures

A very classic stock image that could potentially find a variety of uses. However, it's a safe bet this image would be passed over because of the lady's inappropriate and hazardous footwear. Pointing with the finger is also a cliché and might not prove favorable with some designers. If deemed necessary, use an open hand and point with all fingers. Be aware of propping and styling; poor choices can nullify an otherwise nice working picture.

→

Bright sparks

A robotic welding assembly line can be used for annual reports and a variety of PR or editorial uses. Ensuring these types of images are property released will expand sales potential beyond the restrictive editorial market.

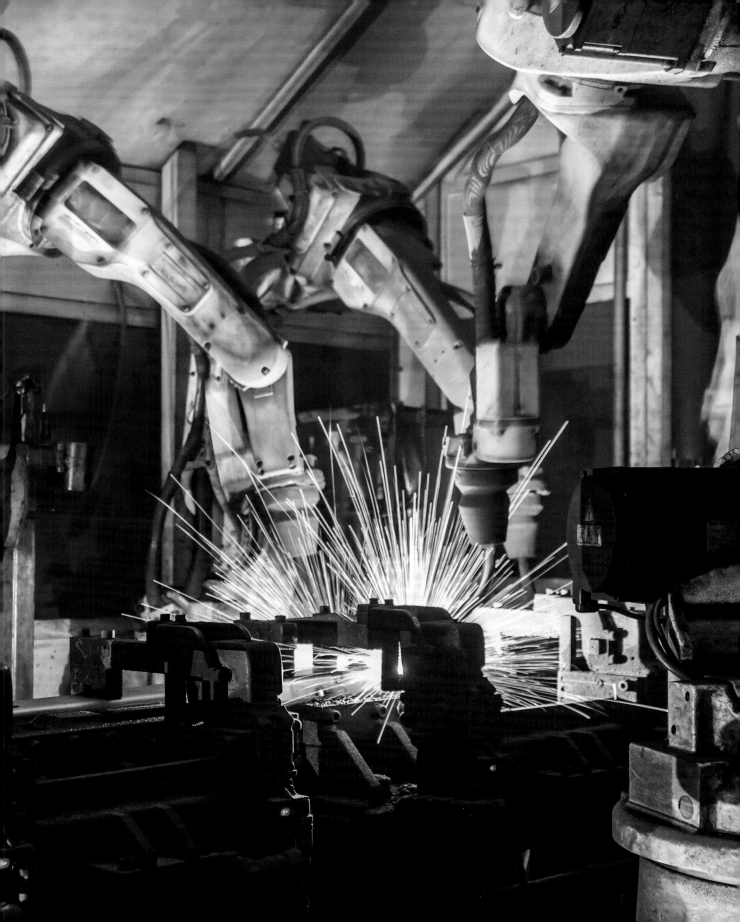

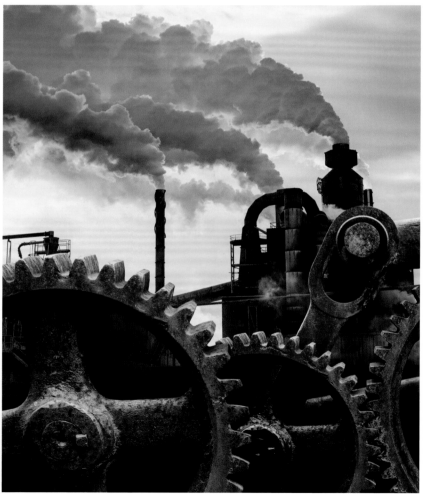

←

Crafting images

"Industrial" often conjures images of big industry like oil and construction. There is also a large craft industry that relies on hand tools and the skill of the craftsperson. Imagery targeted at this industry is a great opportunity to include the primary components of image design, such as detail and still-life setups. Pride in craft and personal satisfaction are buzzwords that will direct how such a shoot should be approached.

↙

Creating a narrative

This is a great environmental impact image that tells a story. Be aware that negative images tend to get less attention than positive images. Happy pictures sell to advertisers.

→

Well-oiled machinery

A hard-core, gritty image that will always find a use in the oil-and-gas sector for editorial and annual-report types of uses.

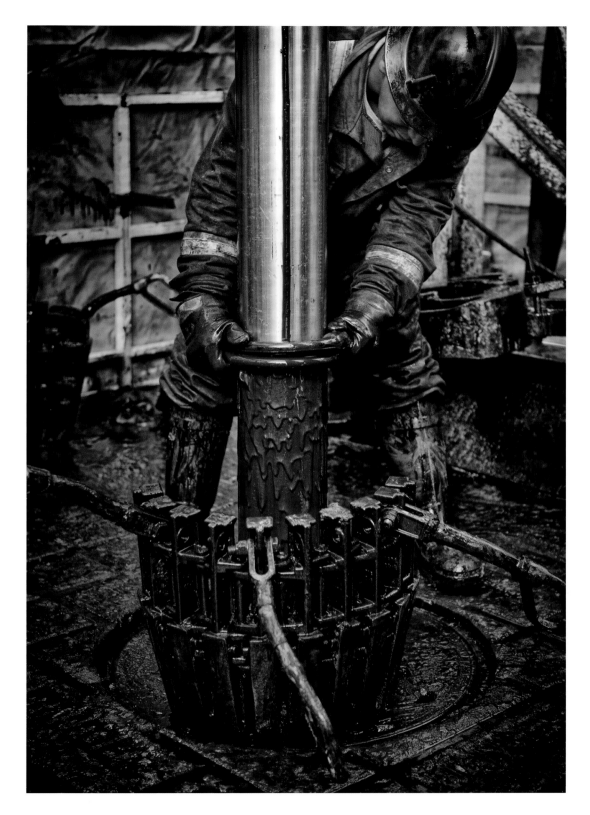

LANDSCAPE

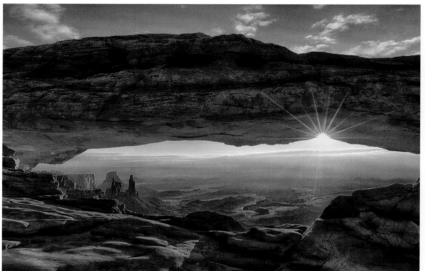

↑

Pretty pictures

There is not a landscape or travel photographer living that does not seek out and make images of iconic landmarks. They will ultimately sell but not nearly as well as one would hope. To make a long story short, these are pretty pictures and not working pictures. Nice to visit, a lot of fun to photograph, but don't expect to make too many mortgage payments.

→

People sell

The smart landscape photographer monitors their royalty payments and soon realizes that once a person is introduced into the frame the image becomes a working picture. Working pictures are those that sell. Embracing the "location and experience" concept, the photographer can use infrared technology, walk into the frame, and with a small hand-held transmitter, take pictures of themselves walking down that path to success.

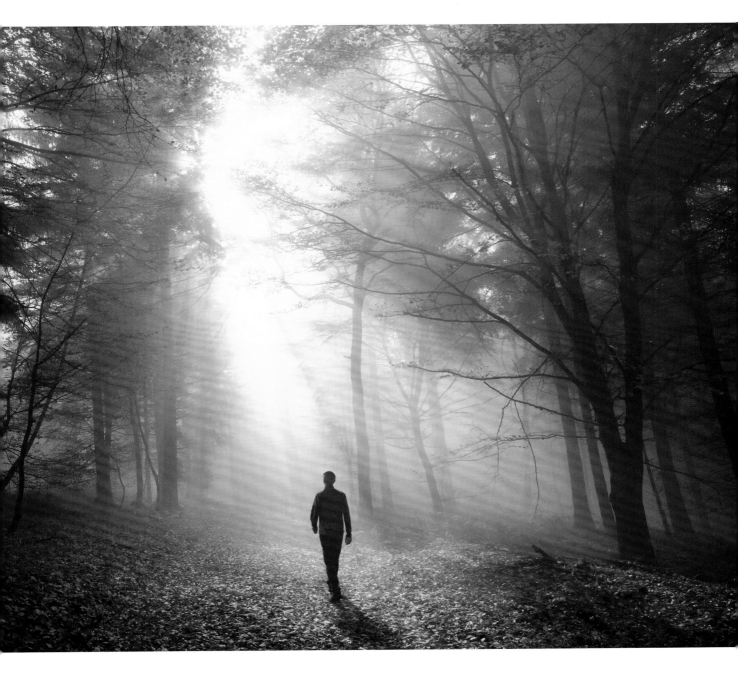

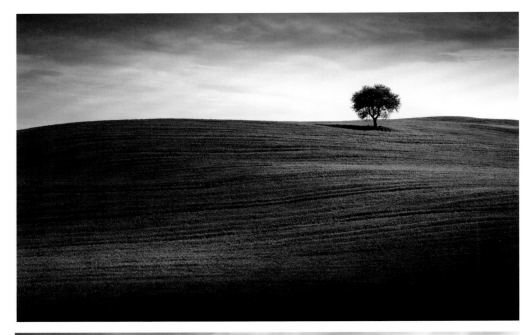

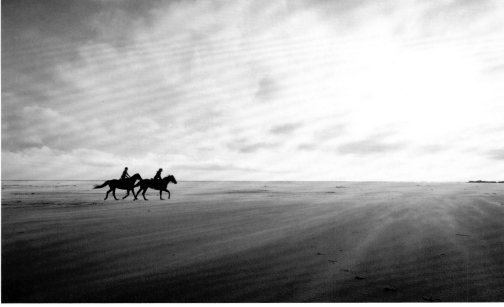

←

Naturally abract

A single solitary item in the frame does not offer as much market potential as a person, but still makes a powerful statement along the lines of survival and strength.

↙

Strides ahead

A beach shot with a rather pleasant sunrise is made so much better by placing galloping horses in the frame. The image could have been made stronger in post production by removing the tracks leading from the bottom right—a small and quick fix that would have elevated the image to an even higher level.

→

Force of nature

Successful landscape photography must play on impact and mood. This image of a known landmark simply doesn't make the grade as there are many, many thousands of images that show the location in a much better light. Tourism operators most likely won't use the image due to safety concerns being generated by the powerful waves. Additionally, always be aware that an art director can make a black-and-white image from a color file if they so wish; conversely they cannot make a color image from a grayscale file. Make the photo buyer's decision a hard one, not easy.

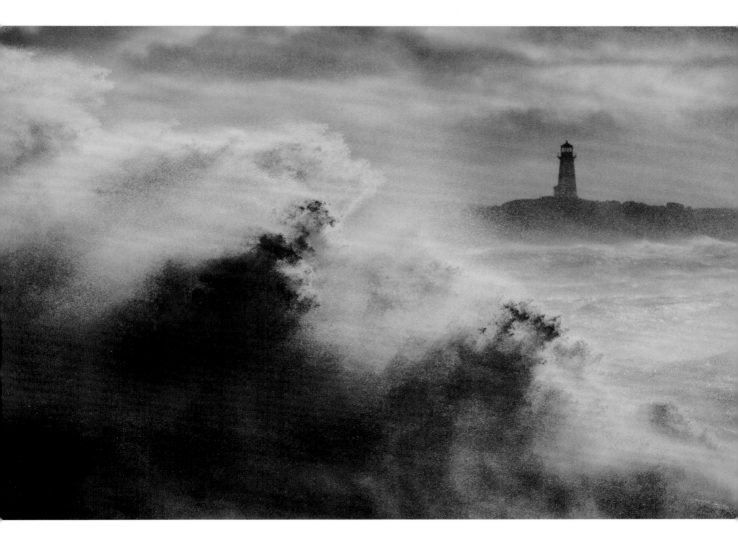

MEDICAL

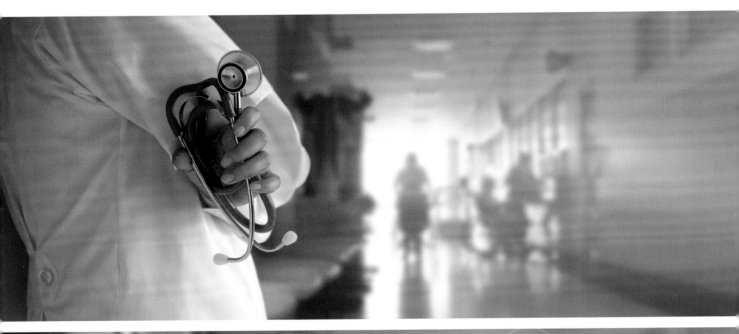

←

What's the focus?

This a classic shot of a doctor in a white lab coat with a bit of a contemporary twist. The out-of-focus background allows the photographer to sidestep the need for model or property releases. On closer study it also becomes apparent this could easily be a composite (which it is) where the doctor has been shot against a green screen.

↙

Combine graphics and backdrops

It is not until you look at this image that it becomes apparent that the doctor in the white lab coat in the previous image was dropped-in during post production. The graphics in this image have been created and saved as a vector file, which allows the photographer to use the graphic in many different medical situations by simply replacing the background. These two images show a photographer maximizing the potential of their images by working efficiently.

→

Clean details

This is a simple still life that has been photographed with the knowledge that it will most likely be used in a non-high-profile role. A well-placed prop in a simple situation provides a timeless image, yet is often lost in the noise because everyone else is also doing the easy stuff. Step away from the crowd, and up your game.

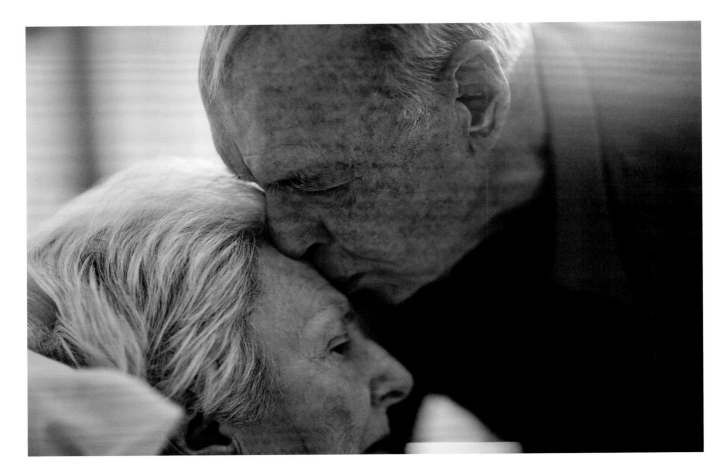

↑
A timeless concept

Love comes in all forms and at all ages, its not just for
young couples walking down a beach against a beautiful
sunset sky. This image exudes that concept and as such
can be used in a variety of messages targeting senior
citizens.

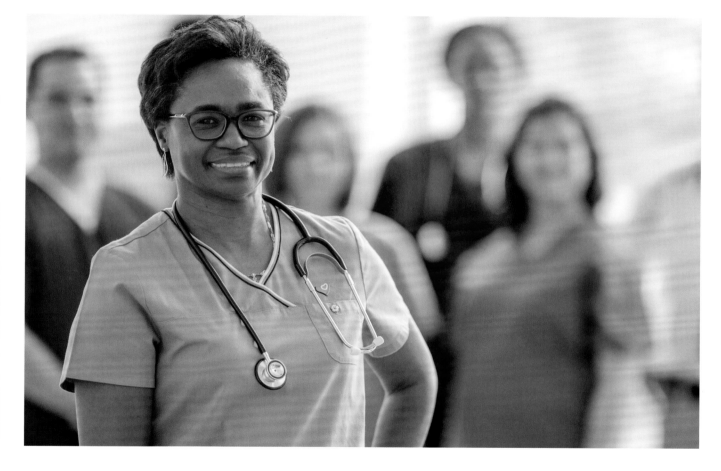

↑
Making it different

A traditional shot of a doc in front of staff. This image
will find additional use due to the model being
non-Caucasian. Some potential buyers may take issue
with the darkening of the eyes caused by the transition
glasses and with the necklace. The bigger problem
with traditional shots, however, is the fact that everyone
does them, and every agency has thousands of similar
images. Be creative and move away from the noise.

REAL ESTATE

←

Building a future

Financial institutions, real estate agencies, and home insurance companies are a few of the potential clients that could use this image to sell their message on how they can provide the building blocks to home ownership.

→

Welcome to your new home

This is an image of happy couple that one can assume just purchased a new home. The use of a shallow depth of field forces the focus to the exchange of keys. While the concept is fairly well illustrated, the angle of the arm holding the keys is awkward and distracting.

↘

Selling a lifestyle

This real estate image goes beyond showing a home for sale by being suggestive and bringing in additional concepts. Here, it offers an aspirational quality, selling not just a house but the kind of lifestyle its owner might expect to lead.

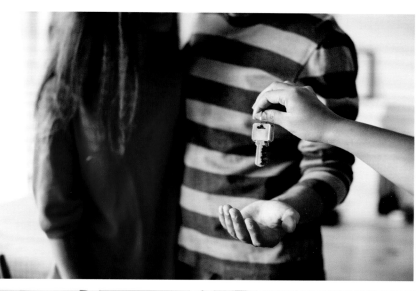

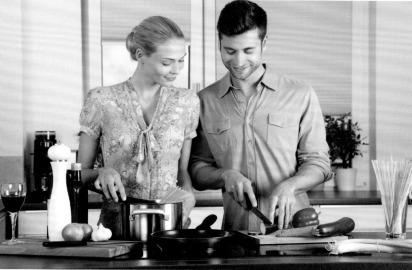

SCIENCE & RESEARCH

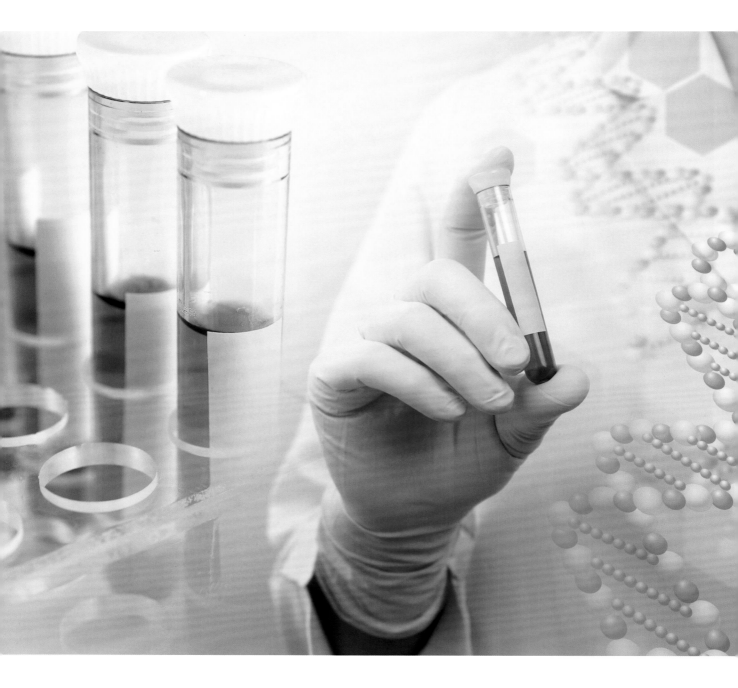

←

Inventive imagery

A classic conceptual science image that was most likely
made nowhere near a lab. A 4ft seamless paper backdrop
on a dining room table and strong window light is all that
is needed. With some post production using layer masking,
it is possible to stitch it all together to create a very
sellable high-key image.

↓

Be precise

This is another image that need not be made in an actual
lab, but can be made in a makeshift home studio. Props
can be purchased or borrowed, but they must be
high-tech lab equipment. Shooting through a glass
tabletop provides a unique perspective. More care should
have been exercised over the composition—instruction
should have been provided to the model to move the
pipette away from their eye. Attention to detail is critical.

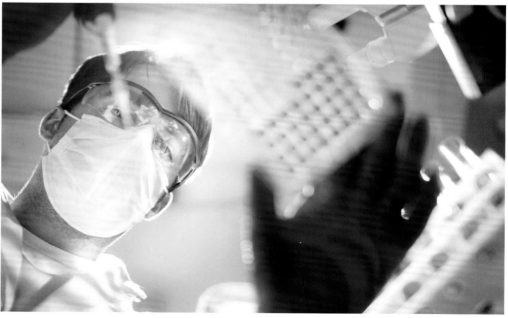

SPORTS & RECREATION

→

Faking it

American football is the most important sport in the United States and has become an important part of community identity and culture. Many young people participate in the sport, learning about teamwork, tactics, and success while aspiring to become professional players. Photographing pro players at field level is next to impossible, hence CGI and post production is necessary. Even the best creators make mistakes: the football has a partial white stripe on the bottom of the ball (amateur and college football) and no stripe on the top of the ball (pro football). This very small detail could seriously limit its use.

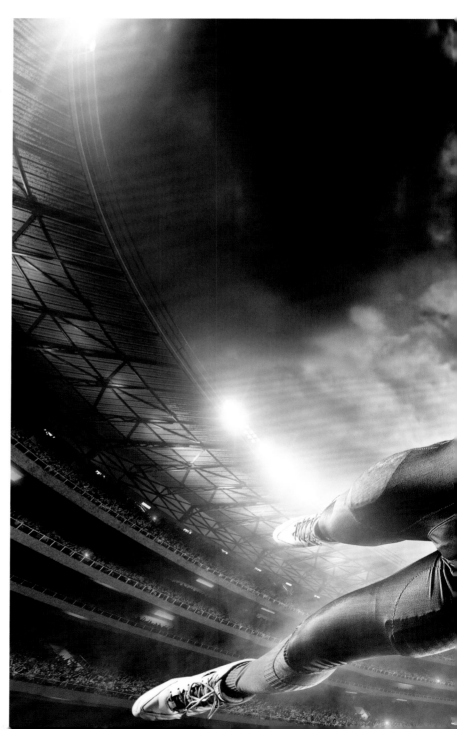

↑

In the green

Golf is a sport played all over the world, thereby offering huge potential markets for golf-related stock images. The photographer can work from one green and putt to success by working up a range of concepts, from a serious athlete problem-solving a shot to a retired group of seniors enjoying quality time. Assume all golf courses are private and will require a property release.

→

Kids and animals

There is a mantra amongst stock photographers: kids sell, happy kids sell better. This future Olympian is reaching for success as he stands on top of the world while celebrating victory. By introducing the taglines along the theme of the image, this photographer is able to capitalize on results.

Capturing a mindset

Stock photography is all about creating an illusion.
Working photographs should transport the viewer to the
mindset depicted in the image—once that is accomplished,
it then becomes the task of the copywriter to sell a
service or product. Perhaps this image is talking about
patience as a virtue, or even saying that success comes
to those who wait.

Leisurely sports

Scenes of parents playing sports with their kids usually
evoke ideas about enjoying the simpler times of life, such
as running around a soccer pitch barefoot and losing the
game to a loved one. There is always a demand for
simple, fun, warm family activities.

TRANSPORTATION

↑
Plenty of choice

This is a beautifully executed aerial image that goes
beyond being an image about transportation. The road to
success could also be the road to nowhere, while an auto
insurance company could use the image to talk about
security and peace of mind. Urban planners and highway
construction firms could all be potential clients.

→
Gritty reality

Not all images need be clean and pure. A jam-packed
public transit window in Bejing, China, tells an editorial
story about moving people in a large urban environment.
Sales are limited with this type of material but so will be
the competition.

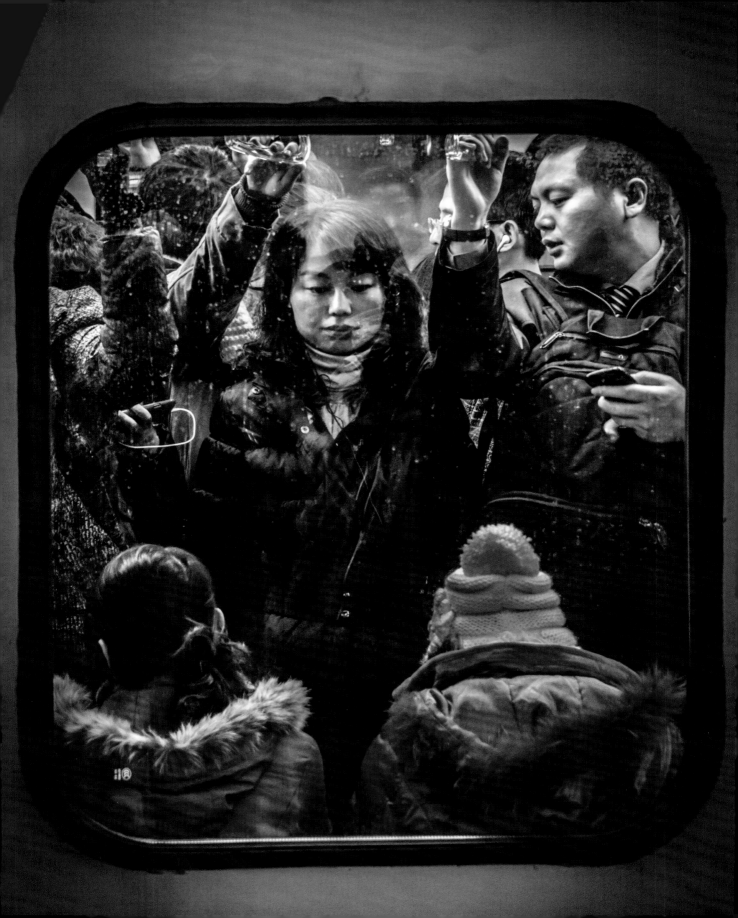

↓
Crossing borders

Images showing the transportation of goods have huge potential, but a truck such as this will be restricted to North American sales. Post-production effects elevate the image, lending it a surreal quality, and it could be used for both advertising and editorial. Photography is an imaging business—the better the image, the better the business.

↓

Blurred meanings

Photographing car lights on busy streets about 30 minutes after sunset can be a lot of fun and can create some great eye candy as a result. But ask yourself: Where might the image be used? The skyline is not generic and the light blur can be confusing. This style of image will most likely be licensed, but its usage is limited by the non-defined content.

←

Reliable fillers

This is a very simple "filler" type image that will never command huge exclusive license fees, but will continuously sell month after month as working images meet a need. Its use is somewhat limited by including only km/h, and the diesel-specific fuel gauge. The tilt-shift-style focus may also not be to everyone's taste.

TRAVEL & TOURISM

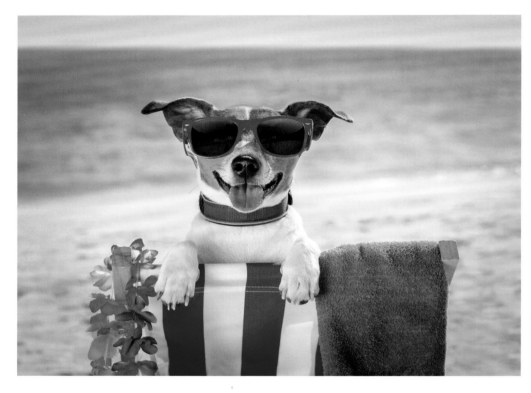

↑
A bit of whimsy

Fun, cheeky pictures generate far fewer sales than one might first imagine. After all, who doesn't love a happy dog enjoying the summer? With some props, a willing pet, and a variety of background photos, these conceptual images can be a lot of fun to produce using green-screen technology, and will show a return on the investment. They just have to be well thought out and executed.

→
Carefree lifestyle

Vacation time is not only about travel. In North America, especially, many families move to a cottage for the summer. This is a time for enjoying the simpler things in life, and as such, the images should be fun and spontaneous. Not only will "country cottage" magazine be looking for content, so too are the service providers and resorts that cater to the free-spirited vacationer.

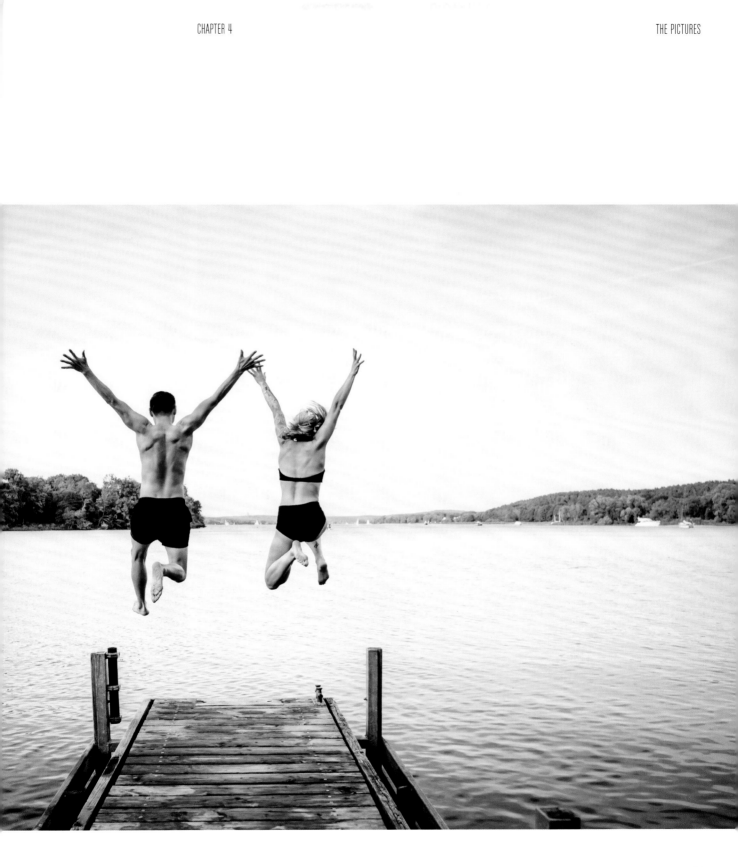

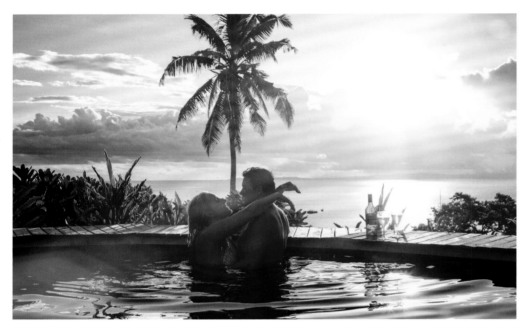

←

Couple's retreat

What is more classic than a romantic couple in an infinity pool at sunset with a bottle of wine? We can only hope this couple's relationship is not curtailed by the palm tree that separates them. This could have been so easily corrected by having the couple move to the right and moving the camera direction to the right. This would have placed the couple in front of the sun, and the palm tree to the left of the frame. Not only would the embracing couple no longer be dissected, the graphic designer would have more room to place text. This is a great location, just poorly executed.

↙

Target market

This is a great image that caters to a very specific and important market: seniors. Yes, it is a set-up image, yet it looks so spontaneous and carefree, and that it why it is so effective. Not only does it meet travel and tourism requirements, but it can also be used in pharmaceutical, health, and wellness, and a whole array of potential other areas. Simple, clean, and generic images will win every time.

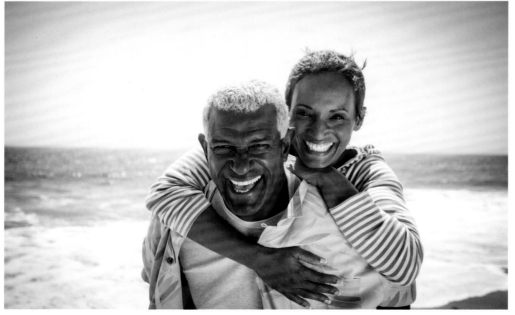

→
Famous landmarks

Tourism destination photography
is what gets many photographers
started, and in microstock especially.
The family goes on holiday and
comes home from some exotic
location, and the budding
photographer thinks "Why don't
I see if I can make a few dollars from
my holiday pictures?" On Getty's
iStock Images there are 4,147 images
of the Leaning Tower of Pisa. When
a filter is applied to seek images
with only two people in the frame,
a mere six images appear. The
working stock photographer would
know this before departure. Research
the locations and learn of ways to
capitalize on the voids.

WILDLIFE

←

Animal humor

Oh ya, I'm cool, dude. Cheeky pictures of critters can sometimes find uses although many advertisers are reluctant to share the love out of fear of being misinterpreted. Most often the use will be for tongue-in-cheek messages as opposed to selling a piece of fine lounge furniture, for example. To the clever copywriter this meerkat could appear to be keeping the lines of communication open and enjoying success.

→

King of the jungle

Wildlife photography is one of the most exciting genres to pursue. However the cost in real terms and in time will also prove it is also one of the most difficult pursuits from which to earn a living. Those who do will learn very quickly that apex predators taken in a portrait style will improve their chances of success. The alpha male lion is at the top of his game, and makes copywriting for numerous advertising uses quite easy for the creative team.

→

Majestic beasts

We often think of horses as domesticated animals. Therefore, when we view images where the equine steeds are wild and carefree we quickly interpret the scene as one of majesty, might, and power.

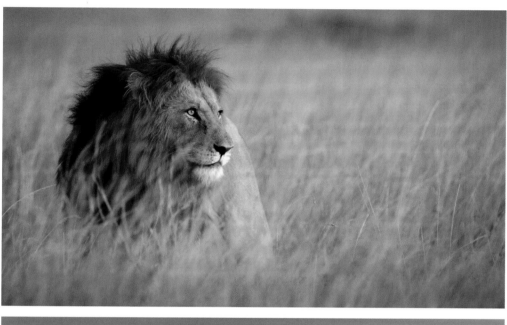

←

Curious critter

The marten is tiny tree-topping fur ball. They are extremely difficult to photograph in the wild without baiting. Consequently, when the photographer is able to get a good frame, it is considered a success. To the stock photographer however, successful images of martens simply do not translate to income. The marketability is very restricted to limited editorial use.

↑

Symbols of the time

Mothers and their babies sell by exuding nurture, care, and love. The polar bear was long used as an icon for many refrigeration and air-conditioning companies. More recently, the polar bear has become the poster child for the environmental concerns of global warming.

CONCLUSION

CONCLUSION

THE MONEY

Should you have read up to this point, you will recall " . . . your revenue from licensing stock has to exceed more than half a million dollars annually just to meet your costs of being in business." This sounds like a lofty number, and it is. It is also contrary to the vast, vast majority of articles on the internet with headings extolling how to make fortunes selling stock photography.

For example, in a blog entry written in 2017, the writer opined, " in my mind, $1 per image isn't all that bad, and can add up quickly." The writer is also a founder of a photography academy and proclaims to be a photography educator. This is frightening for a self-proclaimed educator to suggest that $1 per image isn't all that bad, and especially so when he neglects to mention his gross net income from that image is most likely only 20 cents!

What worries me is that no one really wants to talk about money. How can we—as a collective of knowledgeable photographers—continue to write about our profession as we did pre-2008 and the great meltdown? The reality is that very few stock photographers today enjoy net incomes exceeding $50,000 per year exclusively from their stock portfolio.

The reason is quite simple and harkens back to Jonathan Klein's New York address:

"Customers expect more and more value at the same cost or even a lower price." One can only speculate that Klein never recognized that a lower price would ultimately translate to zero. Once the agencies began to undercut competitors by lowering prices, the race to the bottom was on and photography crossed the threshold of licensing intellectual property to an open commodity-based marketplace.

While it remains true the image is being licensed, many microstock photographers review their portfolios to see how many "views" they have received and somehow translate that to success. Is this attitude a by-product of social media where success is viewed as likes and shares? I challenge any photographer to redeem these likes, shares, or other social media accolades to hard currency at their banking institution.

↑
Aim for the skies

As a startup, the photography entrepreneur has to be firing on all cylinders in order to reach any level of success. It is paramount to work smart with clearly defined short-term and long-term goals.

If a photographer wants to be successful tomorrow, they will have to work considerably harder and considerably smarter than their associates just a year before them. The first way to work smarter is to acknowledge that legal tender—hard, cold cash—continues to be the currency of trade. Being a social media celebrity with millions of likes and shares will not translate to sales of stock images.

The reason no one speaks of income is quite simple: If a photographer indicated their revenue was $50,000 per year, every newcomer on the planet would be reviewing that portfolio to see what they were shooting and how they were shooting that selling material. The best-paid stock photographers are anonymous.

And what should a realistic financial target be? In today's climate, once 5,000 images have been placed into the market through a variety of sales portals, it should become possible to realize net revenues of $1 per image on file. If you refer back to the "cost calculator" and decide what your desired personal income should be, it can quickly be determined how many annual sales are needed to reach that security. Generally, about 5,000 images need to be in the marketplace to estimate a month-over-month average sales volume and per image value. Depending on the genre of material you produce, the quality of that material, and how it is being marketed, it is quite possible the per image sale average may be higher or lower than a forecasted $1 net.

↑
Keep a tight focus

The stock imagery of tomorrow will have to have a clear focus. In order to work as efficiently as possible, you need a well-defined business model and a thorough grasp of it.

LICENSING MODELS & DEALING WITH OVERSUPPLY

When Mr Klein directed Getty contributors to create better content for the royalty-free market there were still just the two options for photographers and the publisher—those being the Rights Managed and Royalty Free models. Both models licensed intellectual property. When iStock came to the scene it created a third option, microstock, and the introduction of a commodity-based market. Microstock lowered the royalty due to the photographer by increasing the earnings retained by the agency. The client continued to enjoy a lowering procurement cost. What was happening as a result was a phenomenon no business administrator has yet been able to satisfactorily address: oversupply of content.

Microstock has opened up the stock photography profession to the masses. Anyone with a camera or mobile phone can contribute material to a lengthy line of agencies. The result was inevitable:

- Professional photographers complain of losing control over the pricing of their work.

- Publishers of stock photography complain there is simply too many mediocre images in individual agency collections.

- Agencies complain of reducing returns.

- Agencies transfer the task of inputting metadata to the contributor in order to save on staff costs.

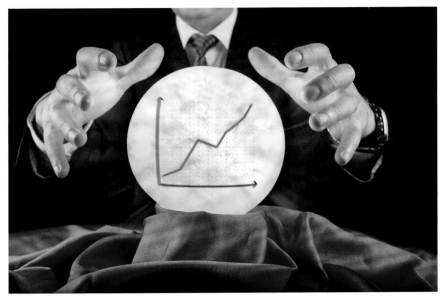

Mr Klein was correct; the client drives the market place. Should the client be complaining of a glut of mediocre material available, how could the agency meet client demand without editing and removing the many, many millions of mediocre material in their collections when they have long heralded the volume of their collection as a marketing strategy?

The agency's answer has been to provide a custom content service. Large corporate entities will contract the agency to deliver custom content, images shot exclusively on-demand, meeting a pre-determined set of criteria. The agency then sends out a photo call to subscribing photographers who shoot material for submission. Once the deadline is reached, material is sent to the customer. This would appear to be a win/win situation; however, the experienced photographer has every reason to be concerned:

- Should the client retain just one image from a series, the photographer cannot submit or license the remaining similar images from the series.

- The photographer receives a set dollar amount should an image be retained, yet

↑
Planning for the future
Luck should not enter the equation at any point. The industry is advancing so rapidly that what was once a five-year business plan has become a three-year plan, and now it is not uncommon to also have a one-year plan in order to stay focused on advancing trends. Only some divine intervention can help when forecasting what will be in demand in three years' time.

no indication of what the sale price of that image might have been.

- The photographer agrees to essentially relinquish copyright in the work as the customer retains all rights in perpetuity.

- The client gains new edited, exclusive, and previously unseen content, presumably with no production cost, just the negotiated price with the agency, which is not shared with the photographer.

Only the individual photographer can decide whether the custom content market is right for them. Care must be taken when reviewing the terms the agency is offering, and it is essential the conditions of the offer are thoroughly understood. No commercial photographer (meaning non-stock photographer) would ever accept a commission without having a reimbursement policy for incurred expenses, as well as a kill fee attached to the job should the material ultimately not be used.

In summary, the photographer considering entering the field of stock photography must rub a crystal ball, bow to the rising sun three times, and ask for guidance from the photography gods. If that fails, then an incredibly solid business plan will suffice.

HOW THE STOCK PHOTOGRAPHER CAN SUCCEED

History has indicated there will always be a market for visual content. History has also provided data that suggests the market is

growing in users of the service. This same data also suggests the return on the investment to the photographer is most likely not going to increase, and, if anything, may erode even further. As long as the client increases demands and agencies continue to lower prices to gain market share, the photographer's livelihood is left to the mercy of others to decide.

Just as royalty-free images displaced rights-managed images, so too will

↑

The essence of stock

Good-quality still-life images taken in a studio will always place with agencies and win clients. These low-cost images should become the staple of the microstock photographer. Focus on raising the quality of your images in order to be seen ahead of the competitors. Pours and splashes are always needed.

microstock displace the royalty-free model. Shutterstock, being an exclusive microstock portal, and their incredible growth in sales and value is an indicator of the future. This stems from client demand for increased quality to be available at lower prices.

Should this prove to be the case, and all indications point in that direction, the photographer must adapt in order to succeed. Since the content provider has no input into the value of their intellectual property once it's assigned to a third-party agency, an entirely new and diversified approach is the only logical way forward. The photographer must find ways to meet the requirement of microstock for mass, as well as satisfy client demand for quality images. They must find ways to work efficiently, without compromising creativity. Consequently, I believe the successful stock photographer of tomorrow will have to adopt a three-pronged approach.

SHOOT WHAT SELLS (EFFICIENTLY)

The shelf life of an image with an agency is very short, and typically not more than one year. Recognizing this, it would make economic sense to identify and revisit selling themes every year, and only expend energies on those themes. The material has to be generic, well-executed, and on target to rise above the competition that will continue to flood the microstock market. It should also be produced on very low budgets, and so it will most likely have to be produced in the studio as still life images and comprise what is commonly referred to as "filler" stock.

It typically takes a week to research, design, and develop a shot list, source props, and

coordinate a shoot. Every photographer will also expend a different amount of time in post production; a reasonable time budget should be at least 1:1, where one hour in post is necessary for every one hour of shooting. We can quickly see that one good shoot session will require two to three weeks of work from concept to final closure of the completed files. A one-person studio should aim to produce two shoot sessions per month. Always bear in mind the quality of result will be directly proportional to the attention to detail in pre-production. Think of the quality of the material as the driving force, not the quantity.

IDENTIFY EMERGING TRENDS

Simultaneously, and in order to retain creativity, diversify the portfolio, and seek a better ROI (return on investment), especially on the investment of time—the most valuable commodity. The diligent photographer must start to hone in on current opportunities. What industries are starting to create excitement in your geographical region? Look at agriculture as a broad-based example: are organic farms and farmers' markets starting to generate some excitement? Does the craft brewery craze that is winning fans all over North America have a presence in your neighborhood? Perhaps alternative green sources of energy are appearing on more rooftops?

↑
Fresh interpretations

As environmental issues become more common in everyday editorials, global warming and rising temperatures will lead to an increasing demand for fresh water; both for agriculture and human consumption. How can the photographer visually interpret what will surely be an increasing demand for fresh and new images of water?

The vast majority of players within these broader categories are small Mom-and-Pop businesses that cannot afford a $2,000-per-day commercial photographer. What they can afford is a finely executed stock photograph for $300, for example.

GO INDIE

Identify this dynamic, exciting upstart industry has a lot of players. Produce a series of images that will compete against the best being offered and showcase them on your own website. Care must be taken when writing your license to ensure the client is well aware they might be licensing a royalty-free image, but this does not give them the right to to re-sell or distribute the image for financial gain.

These images must be finely executed and command a premium price. Should competitors come encroaching on your turf, it is essential the price is not lowered; contrary to popular belief, the price can never be raised once lowered. If necessary, increase the quality or create an offer where a client can get a reduced price on every fifth image licensed. The client must see the perceived value as well as the real value in paying a premium for your offering.

Most small business customers will not understand the licensing models, and so it will be down to the photographer to educate them. Educated clients are generally happy clients, so see this investment in time as a cost of doing business, which is compensated by the higher fee for your exclusive royalty-free images. The market will provide indicators as to whether there

is a demand for exclusivity, so pay attention, and be aware that it will mean more work. The returns will be significantly higher, but so too is the administrative burden. Only the client and experience can provide guidance as to whether RM is a viable pursuit. If this image delivery model can be nurtured in a niche market with stellar images, it will most certainly provide the highest return on investment.

One thing is certain—the indie photographer will have to market their business like a possessed demon. If the goods are not seen, they most certainly won't sell. This will mean additional marketing costs, so it is essential to factor them into the business plan. The numbers won't lead you astray—think with the brain and not the heart. Photography is a business, and success will only come with solid business practices.

The obvious concluding question is: Can I earn a living today shooting stock photography? There are so many variables that range from an individual photographer's skill to their possession of solid business acumen to their ability to satisfactorily manage the type of distractions over which you have no control. Then, perhaps, maybe . . . just maybe. ∎

↑
Cater to multiple tastes

By diversifying content and delivery models to meet local markets with clever and clean royalty-free images, the photographer not only increases the potential ROI but should also satisfy the creative desire to generate high-end images. The challenge is to ensure the return is commensurate with input—you don't buy a high-performance race car on a station wagon budget.

INDEX

PICTURE CREDITS & ACKNOWLEDGMENTS

PICTURE CREDITS

Dale Wilson 24, 26 left, 26 right, 27, 44, 48, 49 left, 49 right, 91, 97, 105.

Getty Images Dale Wilson 72.

iStock adamkaz 176b; ah_fotobox 160; alessandroguerriero 148a; Alikaj2582 73b; alphaspirit 117a; Anchiy 140; AndreAnita 181; annedehaas 104; Anupam hatui 101bl; artisteer 124a, 187; atakan 188; audioundwerbung 42b; aydinynr 40; baona 112a; BCFC 43r; Bobbushphoto 150; borchee 152a; BraunS 122; 169al; BrianAJackson 120, 161; BrianLasenby 6; Cakeio 165; Callipso 179b; CasPhotography 119a; Ca-ssis 162; Cecilie_Arcurs 142; chinaface 127a; ClarkandCompany 29; cokacoka 145; Courtneyk 23; daizuoxin 117b; damedeeso 174; danchooalex 146; Deejpilot 112b; demaerre 138; DGLimages 133; Dmytro Aksonov 166; Elenathewise 126; Ellerslie77 85r; Erikona 185; evgenyatamanenko 55a; 131ar; FamVeld 169b; FatCamera 125, 136, 157; fcafotodigital 139b; Feverpitched 159a; francescoch 118; francisblack 149; gemredding 178; GlobalStock 130; gorodenkoff 52; g-stockstudio 131b; Halfpoint 169ar; Imgorthand 177; ipopba 154a, 154b; ivanastar 111al; jacoblund 168; JaCZhou 170; jhorrocks 176a; Jillian Cooper 180; JohnCrux 171; kali9 144b; KYT4N 84; leezsnow 114; leolintang 111b; Liderina 131al; LivingImages 107; luchschen 109; Maksym Poriechkin 64l; malerapaso 119br; marin_bulat 87b; mg7 169r; MicrovOne 53l; Mikolette 8; mkurtbas 155; Muenz 108b; Nastco 38, 39a; 115b; nicolas_ 163; nirat 124b; Oleh_Slobodeniuk 7; pedrosala 129; PeopleImages 9, 20, 21, 144a, 156; phaisarn2517 136, 172; Poike 132; RapidEye 152b; Rattasak 111ar; Rawpixel 116; RomoloTavani 184; RyanJLane 135; scanrail 127b;

shaunl 128, 148b, 153; shironosov 164a; Silvrshootr 113; simonkr 108a, 142; Smileus 150; Solovyova 95; somkku 164b; sorendls 110; sqback 158; Steve Debenport 139a, 141; sundrawalex 70; SvetaZi 37; Tashi-Delek 123; thomasd007 119bl; tomazl 22; TommL 106, 174; Tsokur 134a; turk_stock_photographer 186; twinsterphoto 94; ValentynVolkov 189; vicnt 79r; welcomia 134b; Wi6995 147; WLDavies 179a; xijian 115a; YiuCheung 173a; ysbrandcosijn 76.

Pexels 089photoshootings 159b; Android Blur 82; quimono 173b.

Shutterstock Africa Studio 54; Alexander Supertramp 77a; Andrey Yurlov 67r; Asier Romero 90; Billion Photos 34; Blackboard 78; BlueOrange Studio 83b; Chinnapong 81r; conrado 36; Constantin Stanciu 33; create jobs 51 42a; Everett Historical 88; everything possible 43l; Fotosr52 30a; Frank Gaertner 51l; Georgejmclittle 56; gnepphoto 14; Guzel Studio 74; Hadrian 53r; HappyAprilBoy 83a; Have a nice day Photo 89l; Iryna Melnyk 73a; Karlionau 79l; karnavalfoto 68; l i g h t p o e t 50; LeQuangNhut 31b; Maksym Poriechkin 63a, 63b, 64r; mavo 28; Milos Erdeljanin 87a; nd3000 75b; Neale Cousland 86; Nejron Photo 51r; Ollyy 7; oneinchpunch 60l, 61; OPOLJA 14; Orla 85l; Philipp Dase 41r; Photographee.eu 81l; Piyaset 12; rangizzz 39b; Ranta Images 61r; Rawpixel.com 99; Shaiith 98; SINITAR 55b; Songquan Deng 69l; Stuart Monk 101br; Syda Productions 77b; Volkova Vera 89r; Wallenrock 67l; Yellowj 16; ZoranOrcik 75a.

Unsplash Chris Barbalis 102; Deva Darshan 66; Dil 92; Holly Harmsworth 4; Ishan Seefromthesky 182; Johannes Plenio, 41l; Mesut Kaya 58; Rawpixel, 18, 159t; Zoe Pappas 10.

ACKNOWLEDGMENTS

I have been fortunate throughout my career to have never worked a day. Such was the love affair I had with my craft. However, I started in stock photography before the internet and instant communications. We communicated with a device called a telephone, one that was tethered to a wall on both ends. How many times did I call my first agent Pierre Guévremont at First Light Associated Photographers? Pierre had the patience of a saint, and I am indebted to his investment in my professional development during those formative years.

Christmas came early for me in 1994. It was December and Masterfile president Steve Pigeon was on the telephone. "Would I be interested in working with Masterfile?" Masterfile was one of the world's premier agencies at that time. I believe it was every Canadian stock photographer's dream to be represented by Masterfile. In those early days at Masterfile there were only 50 photographers and we worked directly with individual editors and image researchers. We were a team that was driven by success. Steve and his staff at Masterfile sustained my livelihood for the next 20 years and I am more grateful than they will ever know.

Through Masterfile I was to meet many, many great image creators who would inspire and excite with their incredible content and motivation. Several have become good friends and, despite the miles of this broad country of Canada, we continue to maintain contact. I simply cannot list all out of fear of forgetting one name, but several must be recognized: Janis Kraulis (Vancouver) and Mark Tomalty (Montreal)

have inspired me with their creativity and visual acuity for more than two decades. Janis is well known for his many books on the Canadian landscape while Mark is the epitome of a stock photographer, he is relatively unknown yet is one of the most intensely creative and successful stock photographers ever. But above all is my good friend, confidant, traveling partner, and generally witty and self-proclaimed curmudgeon, Daryl Benson (Edmonton). There simply aren't enough words to describe what Daryl has done with his cameras and how he has influenced the industry—he simply is in a league of his own. I am blessed to call Daryl a close friend, in business and in life.

Any book could not be published without first recognizing the publisher. Thanks are due to Adam Juniper for first reaching out to me with this idea and Frank Gallaugher for steering it through to completion.
In the background of any book are all those people who do the proofreading, photo editing and designing—it is they who bring a book together, and I thank each of the Ilex team for their most valued input. Most importantly, I want to thank my editor Ellie Wilson. Ellie kept reminding me why I should have listened more intently to my many grammar teachers in school—and she did so with tact and graciousness. Ellie, you are the best of the best.

With all of the professional support I have endured, the most immeasurable thanks I owe is to my family. It was Julie who made the many trips to the airport, and suffered greatly while I would enthusiastically explain my next great idea for an image or excursion. Our sons, Aaron and Alex, would often have to endure impromptu modeling sessions while I explored an idea, and they still do. These three people, whom I love dearly, have contributed so much, and in so many ways and continue to do so. I am blessed.